Oregon See-Weed

*high art
for
high people*

drawn by: Michael Schaefer
*of
Ink on Paper Arts in Oregon*

*Other books
(available on Amazon)*
Lines: Quiet Flows, Woven Stillness
Lines in Black and White
Sines, Tangents and Cycles 1 & 2
Portals 1 & 2

FaceBook: Iopa Inor
Imgur: IoPA inOR

Special thanks to:
Lou, Sonia, the Greenfield Cartel
& other denizens
of the Pacific Pearl Café
in Seaside, Oregon

copyright: 2016 by Amazon/CreateSpace publishing

All rights reserved.
No part of this book may be reproduced or copied without written permission of the author.

**ISBN-13:
978-1537334486**

**ISBN-10:
1537334484**

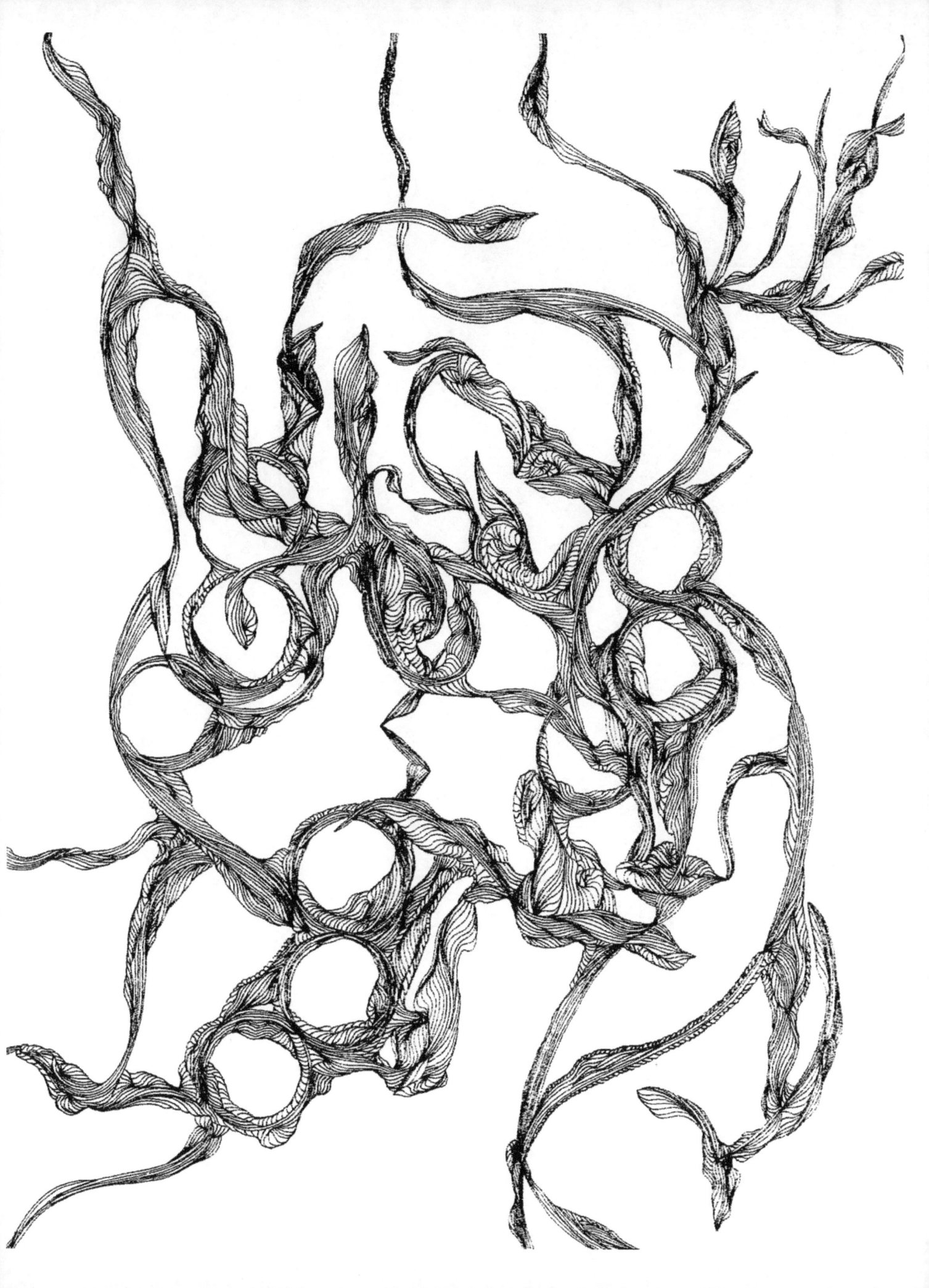

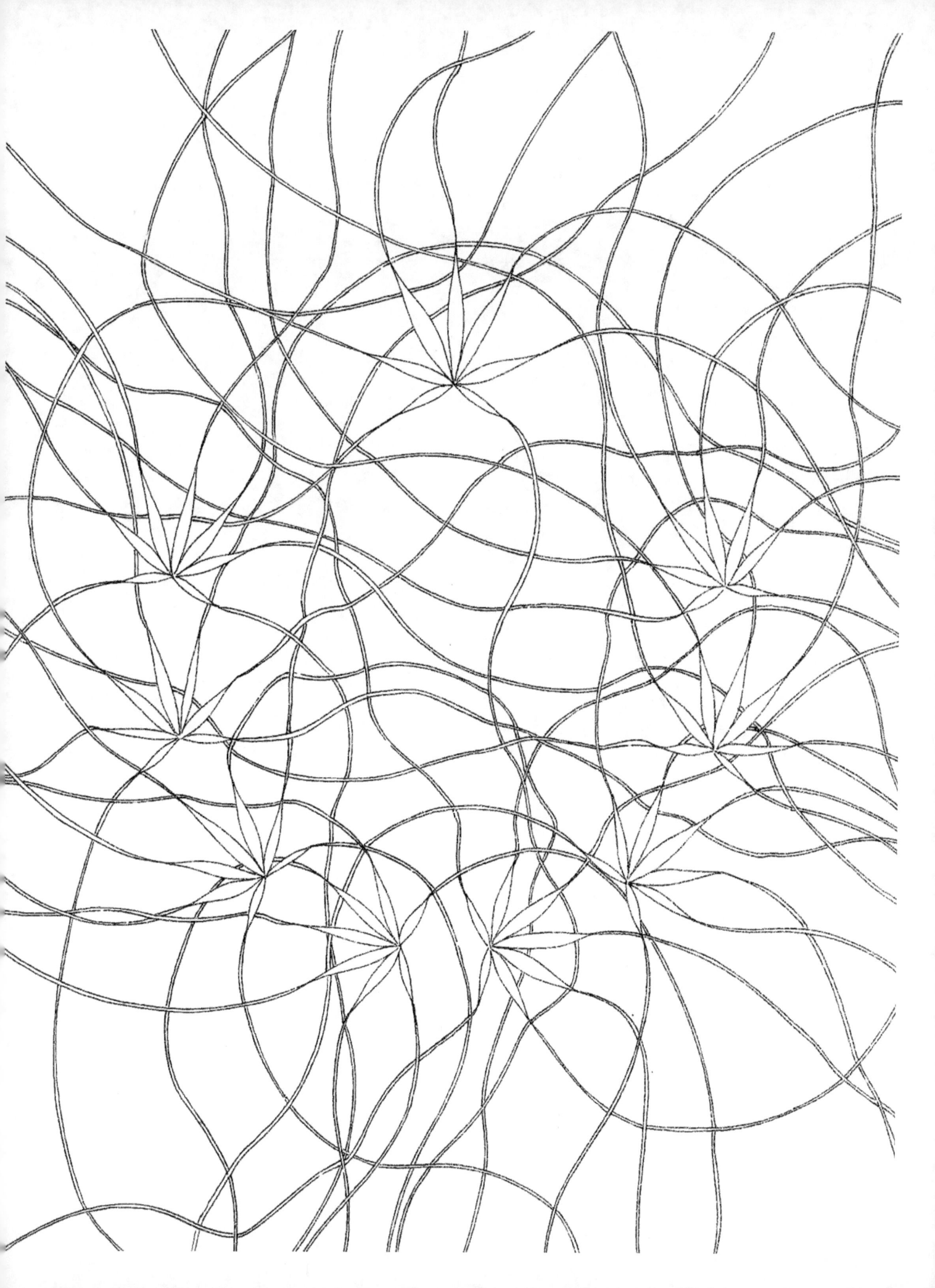

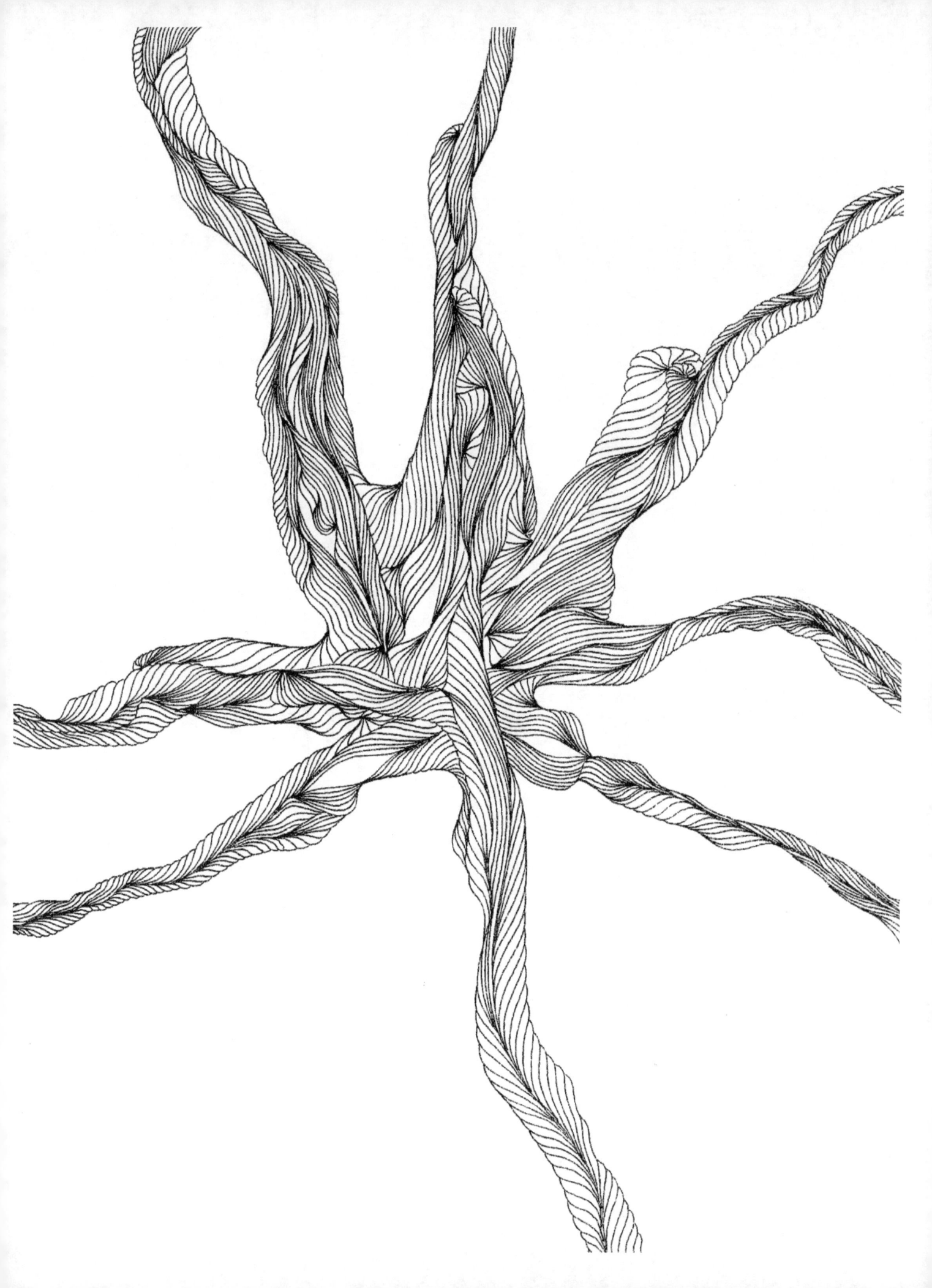

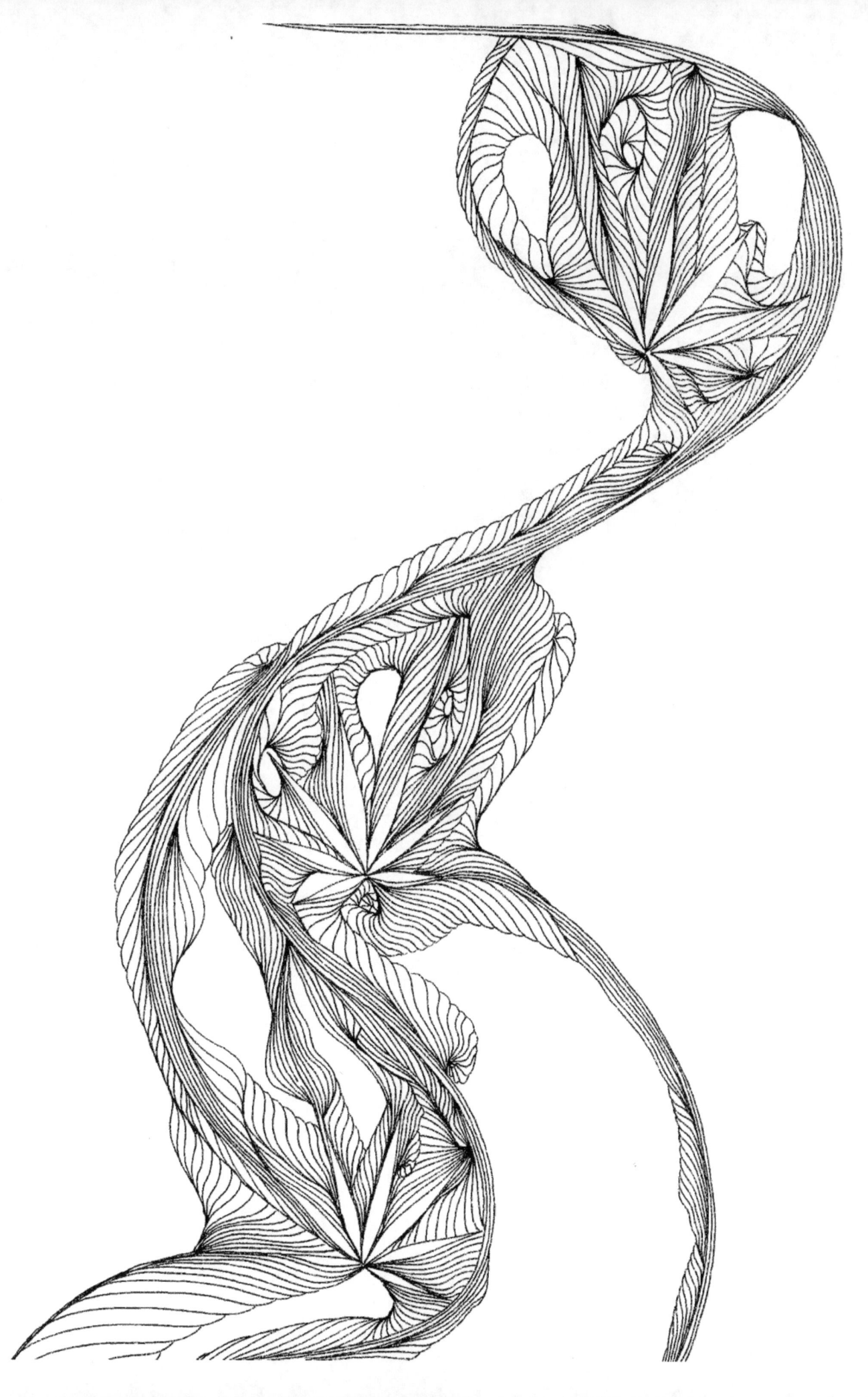

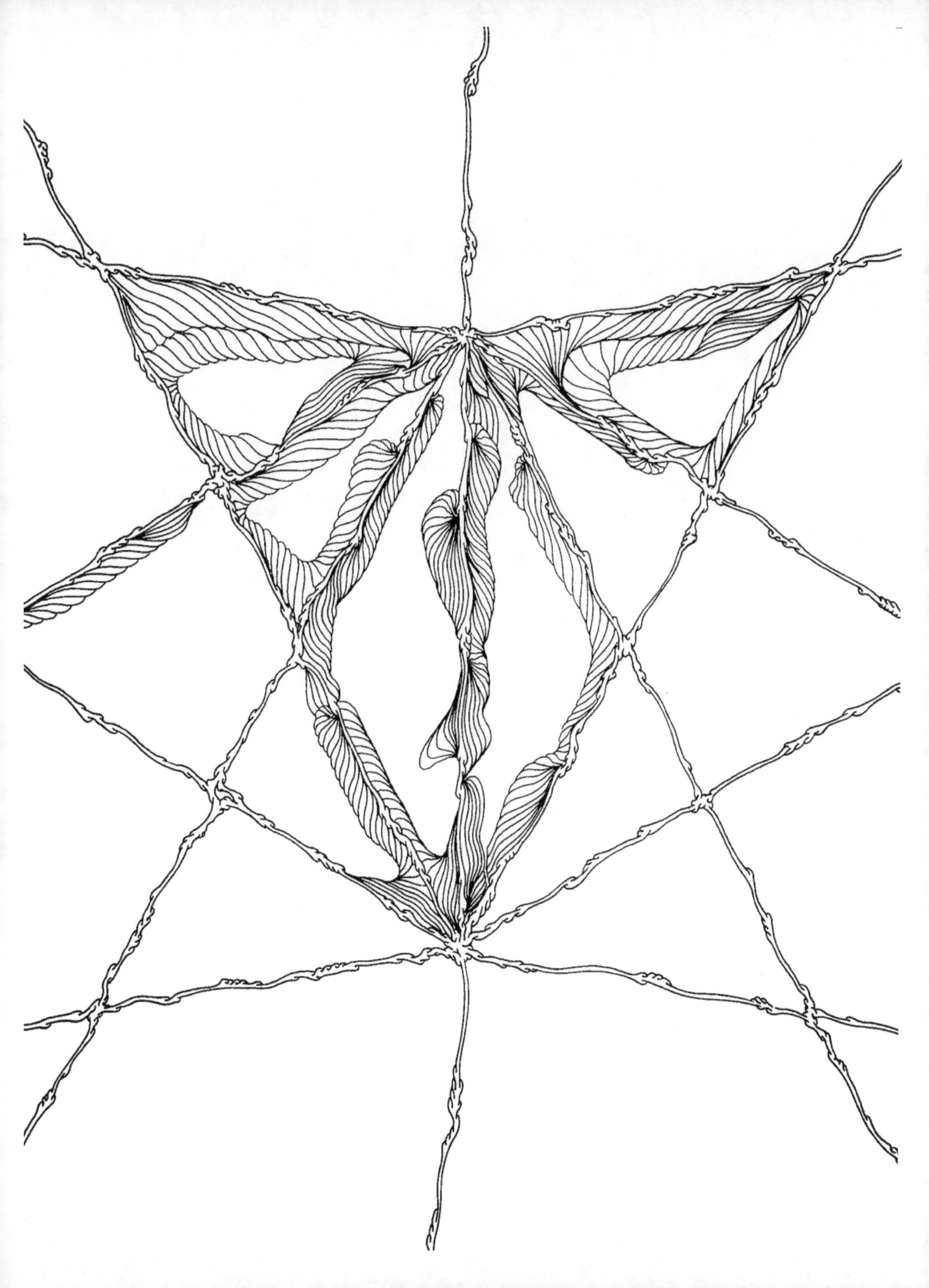

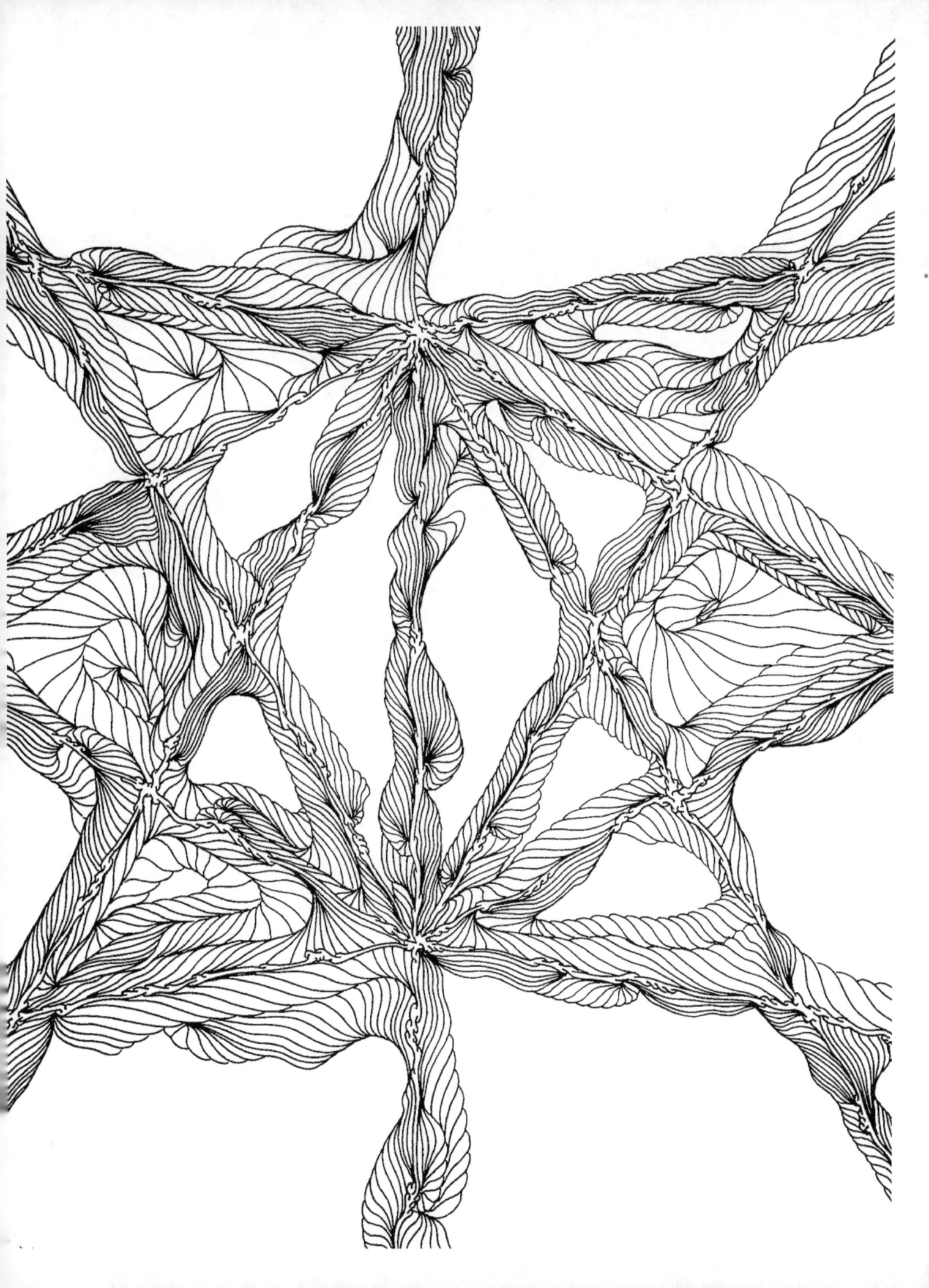

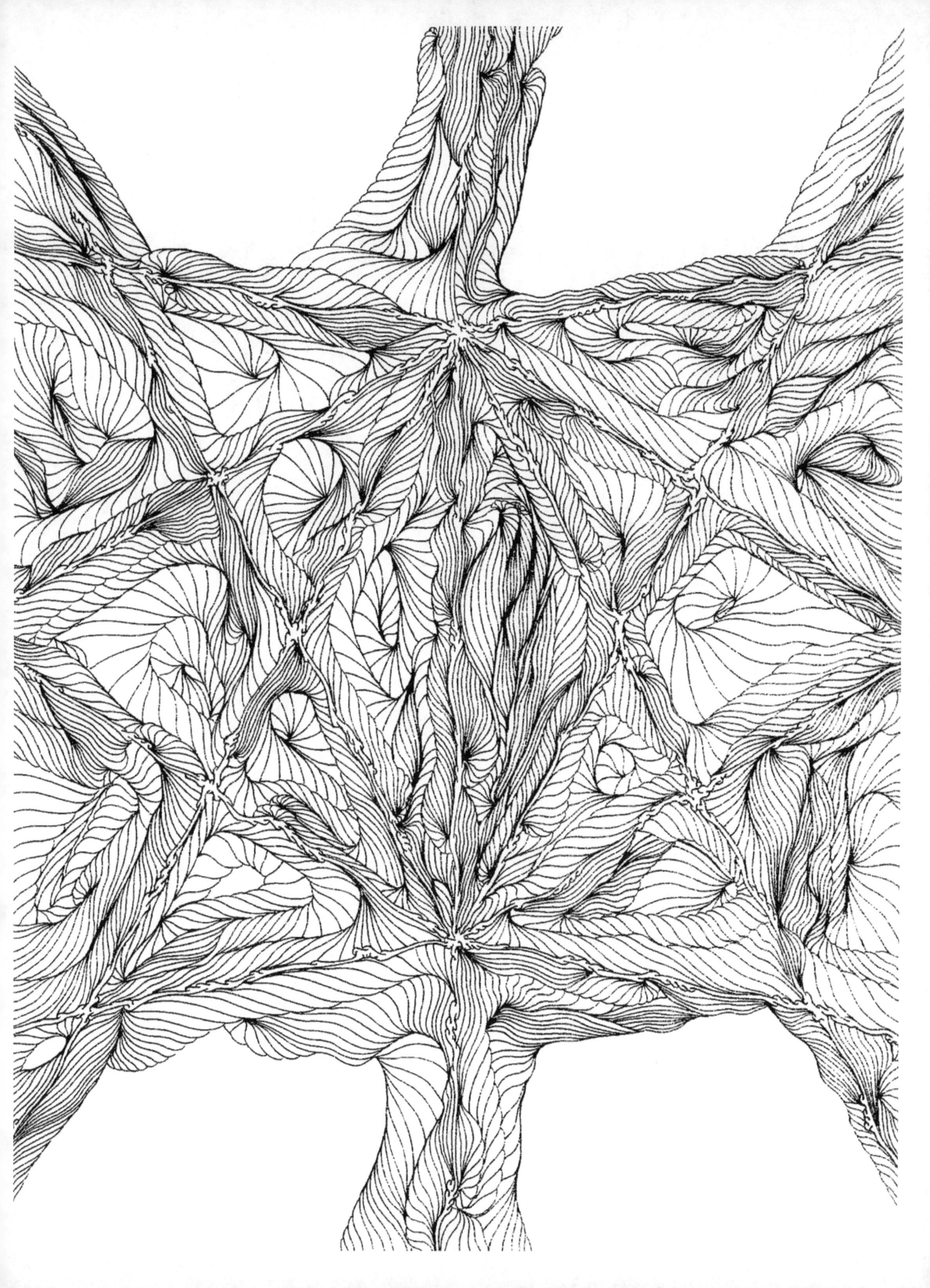

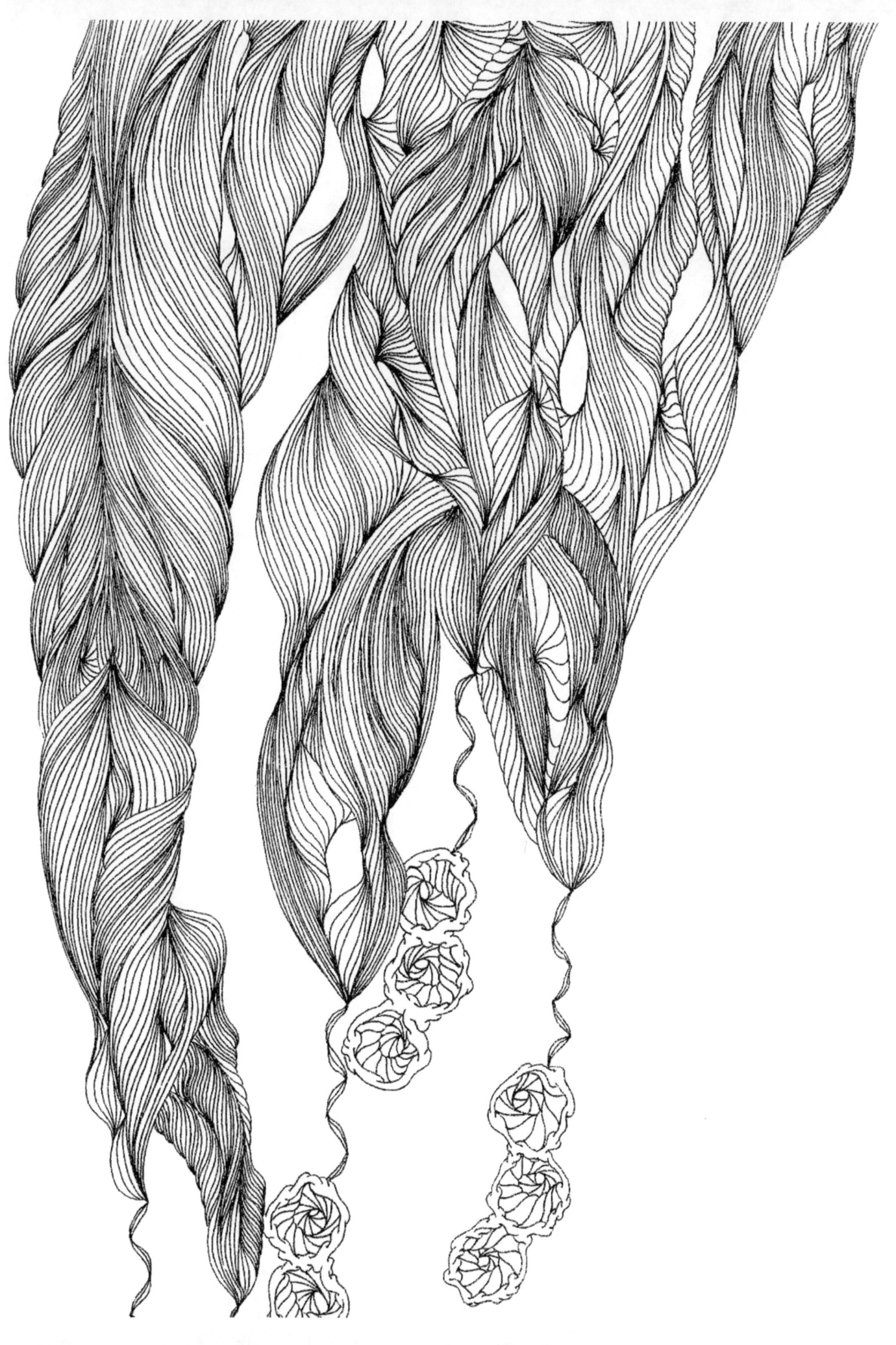

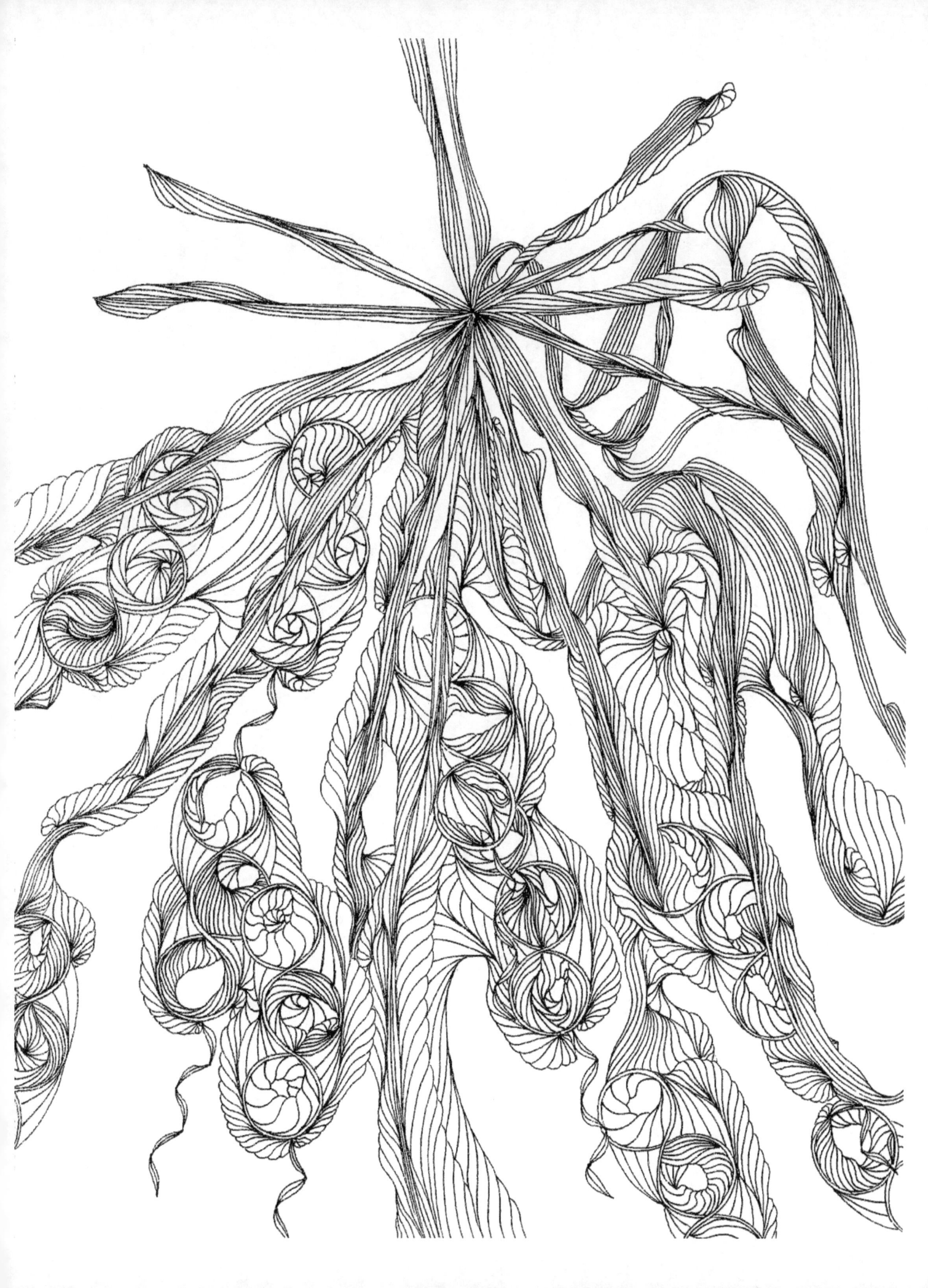

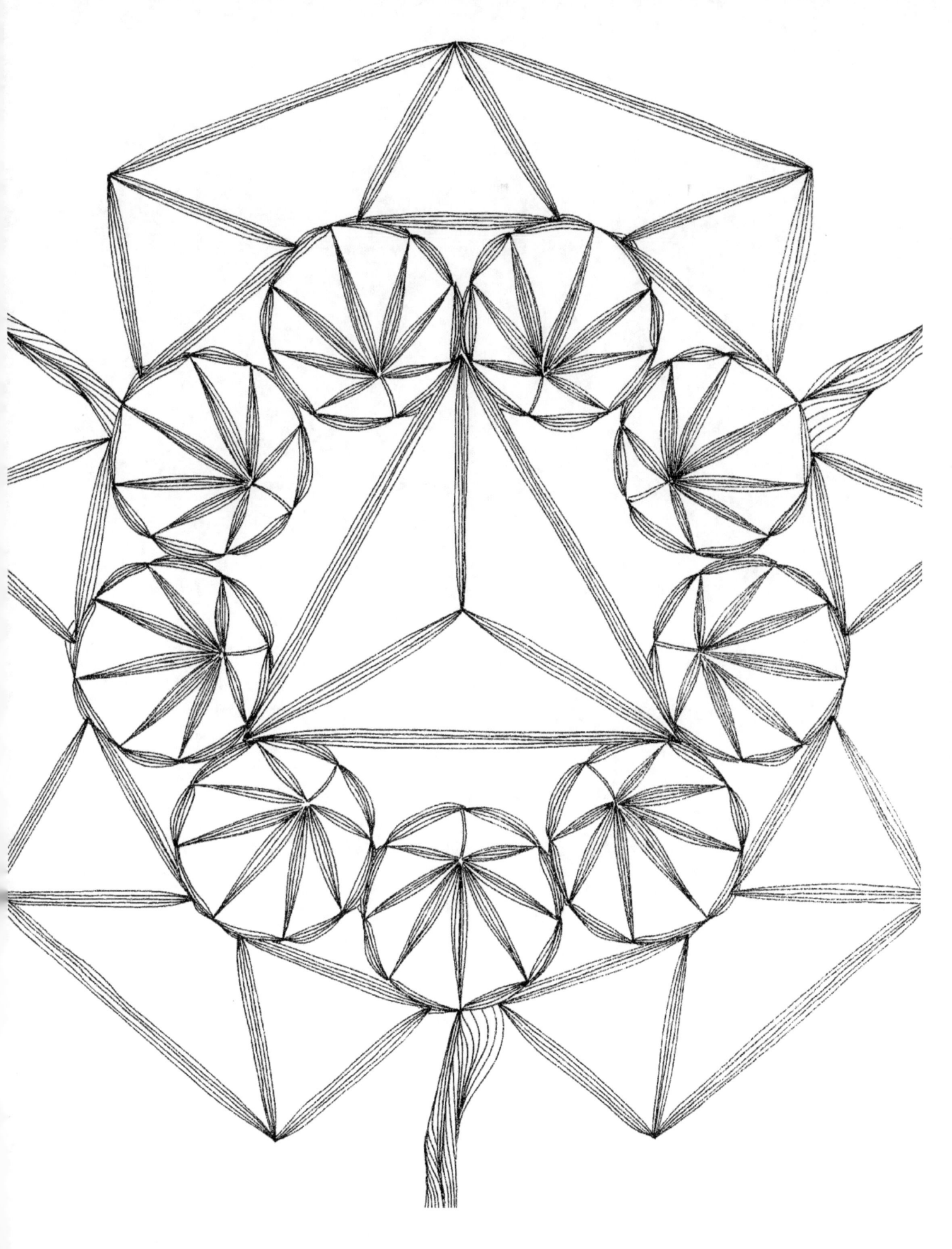

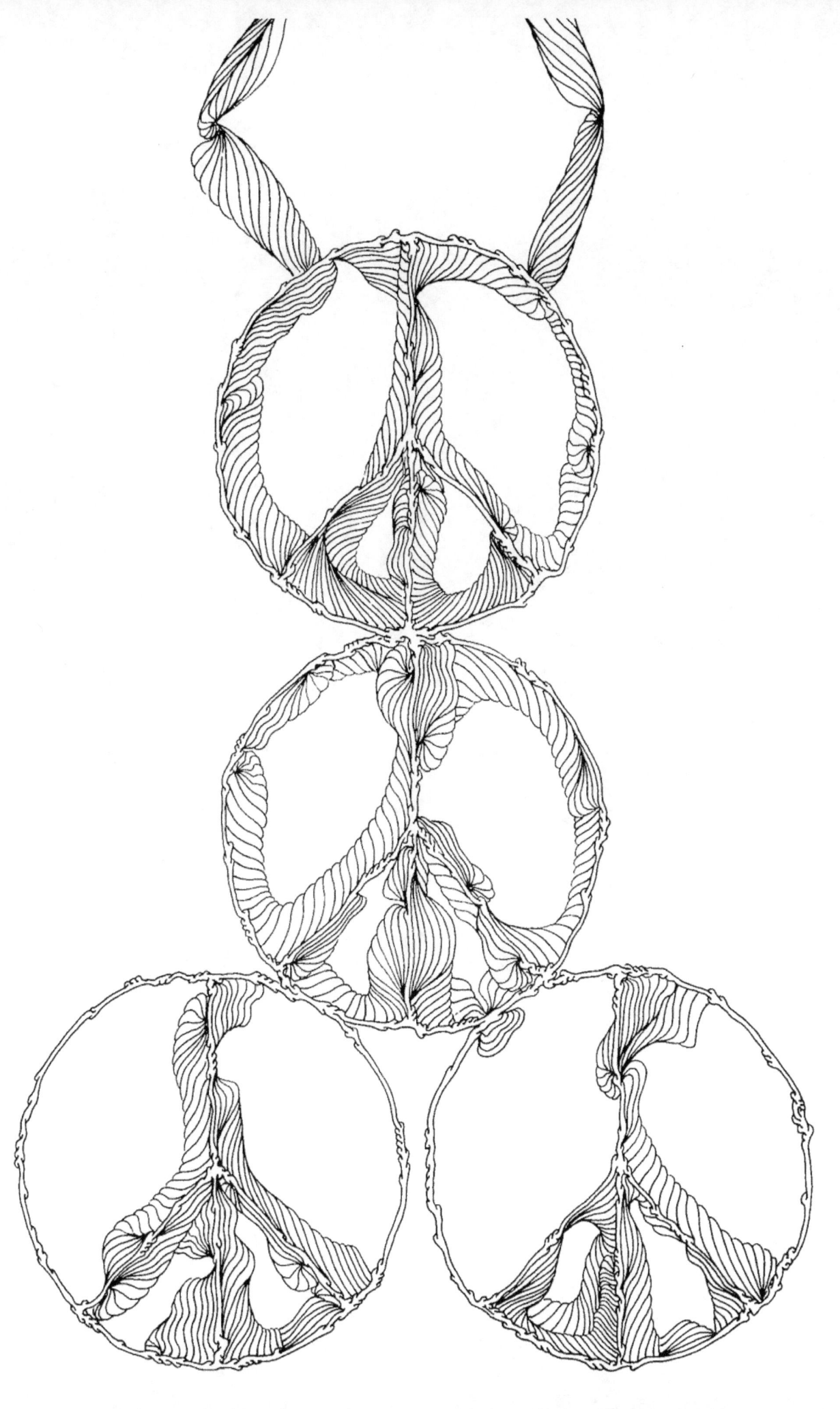

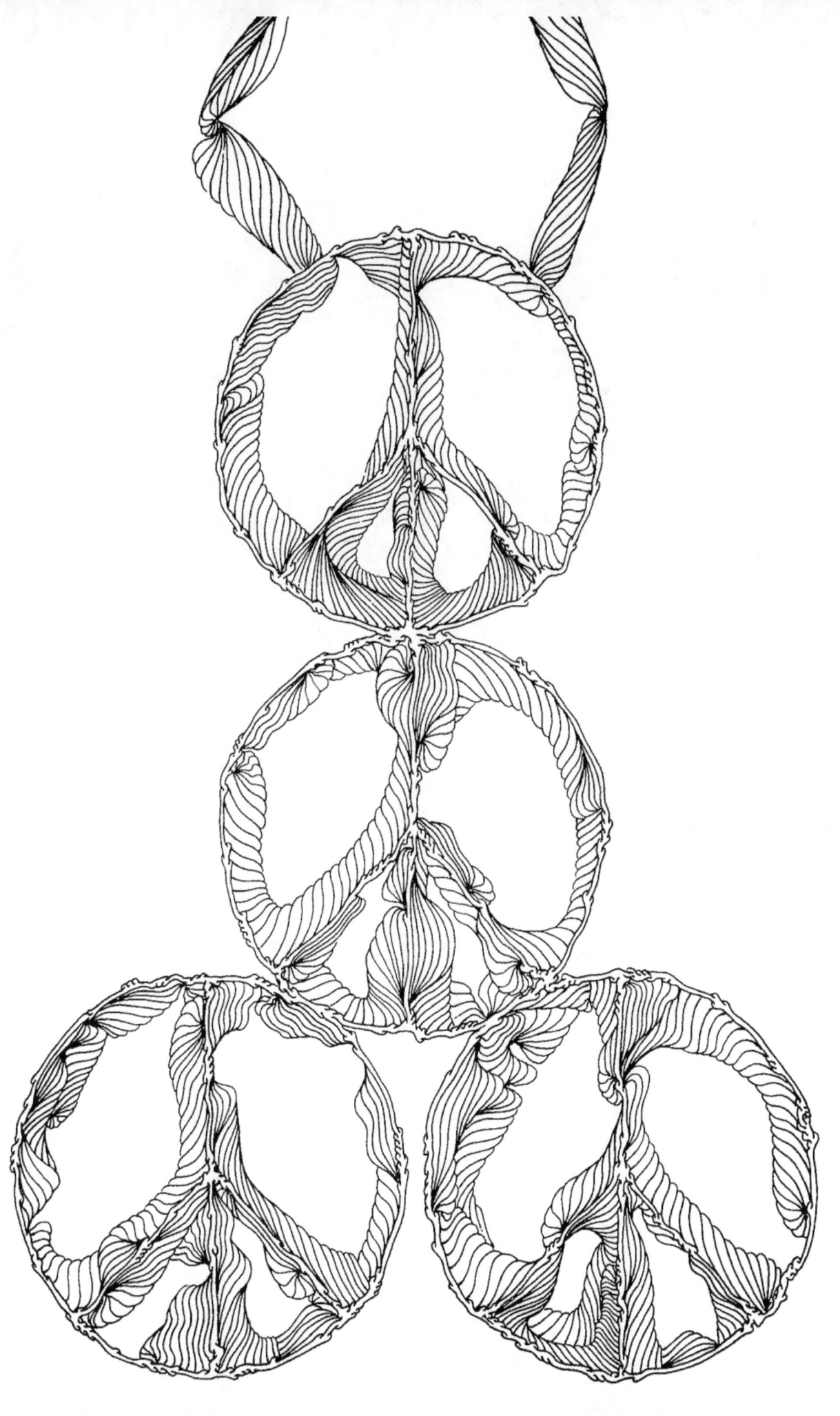

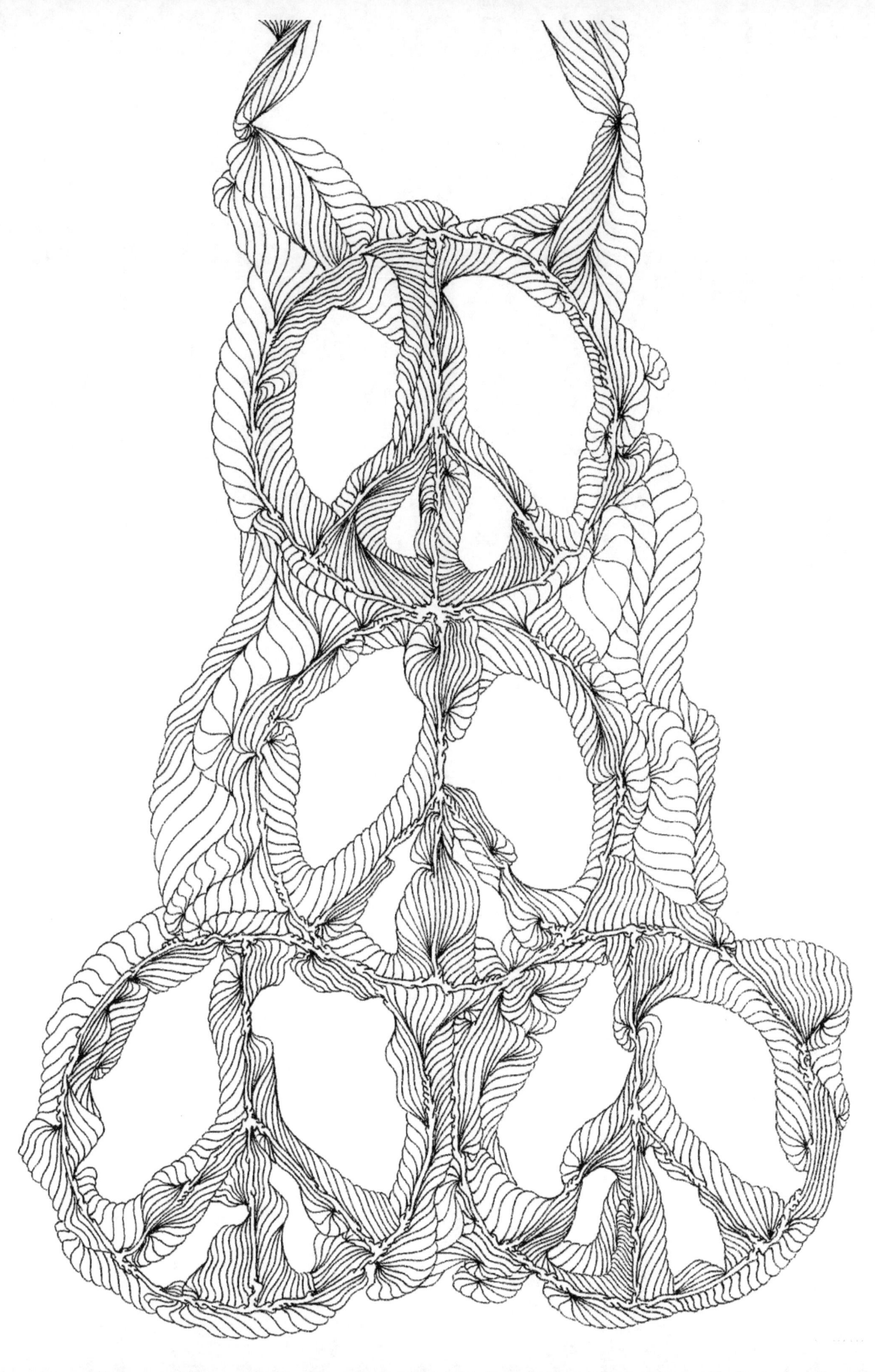

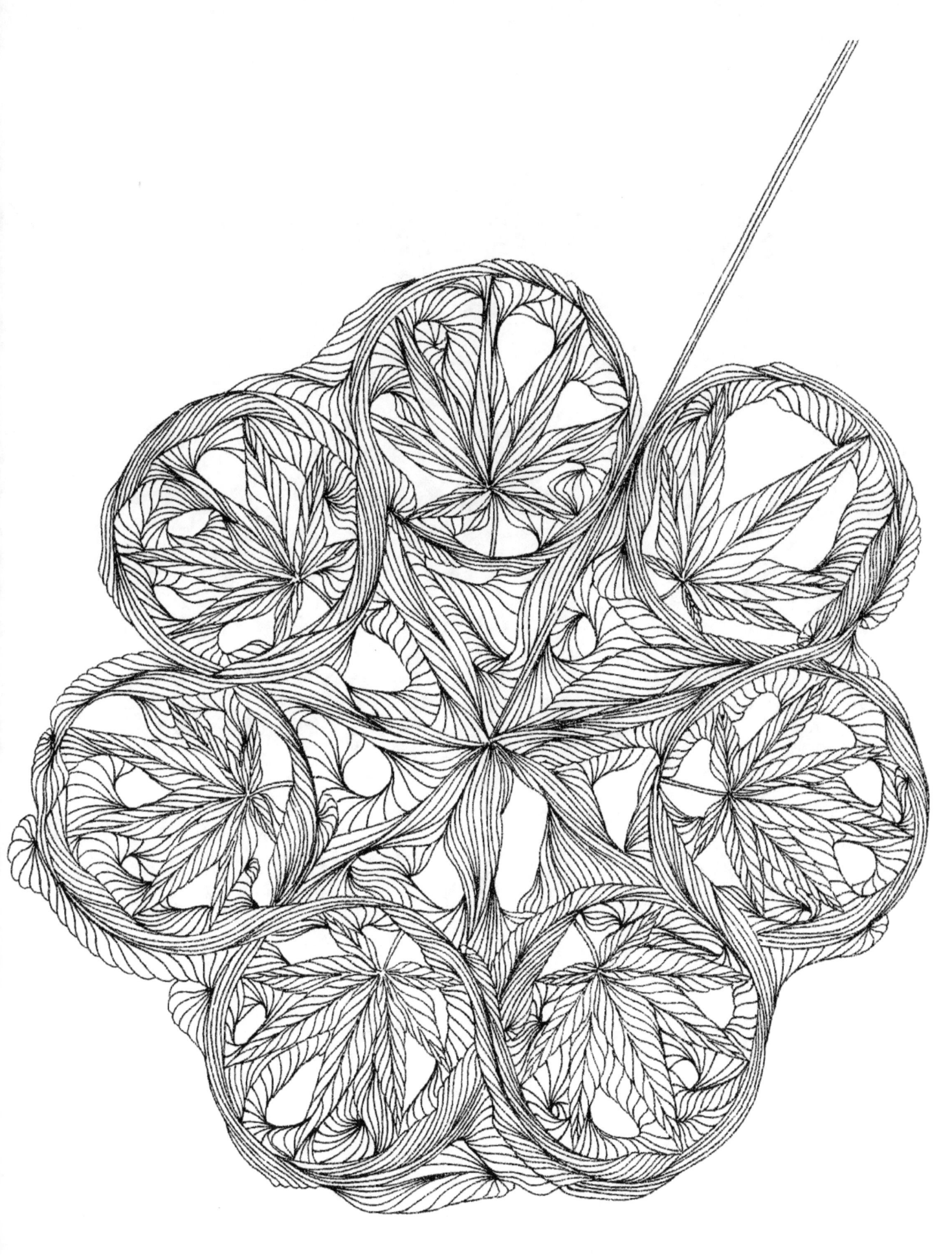

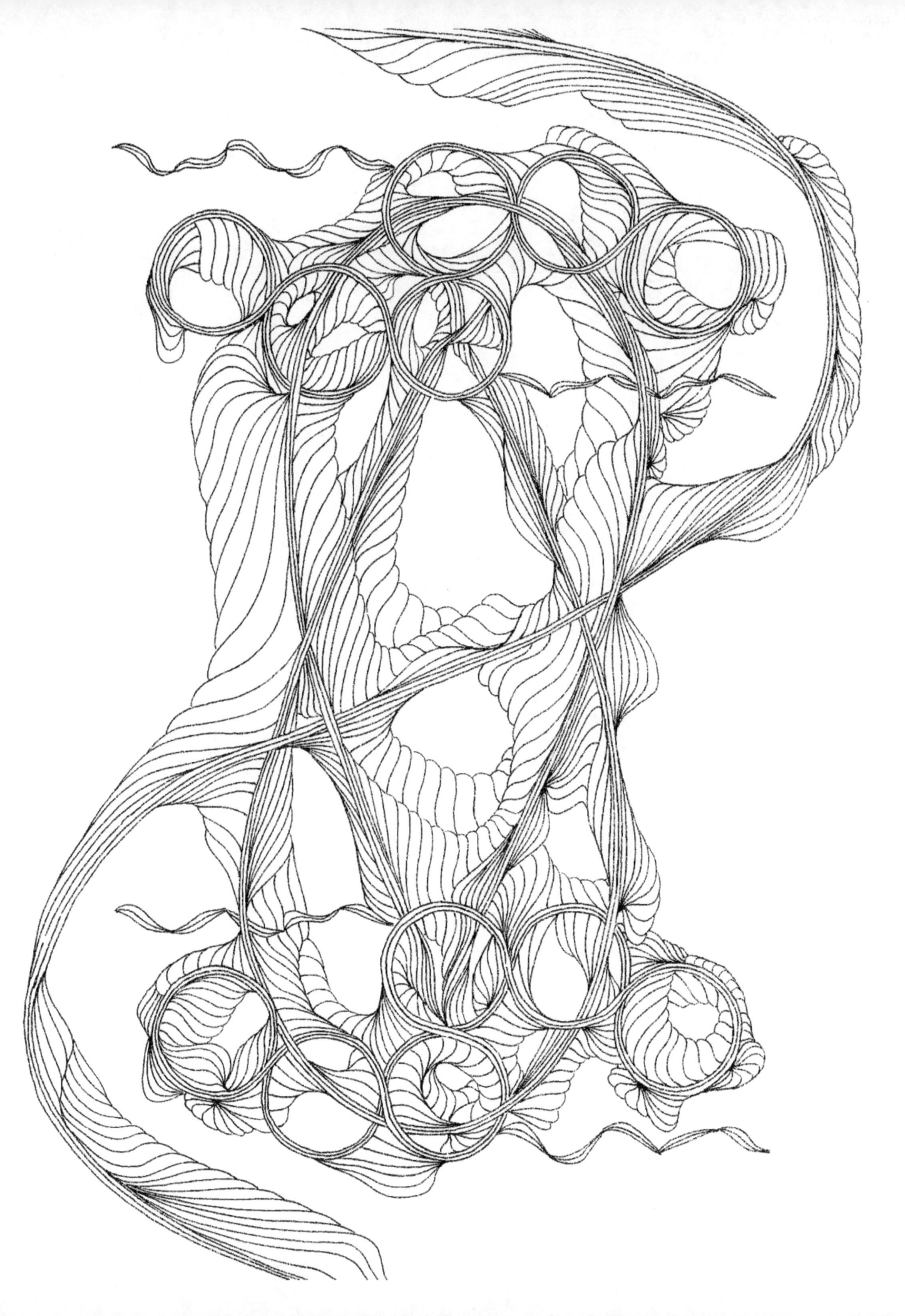

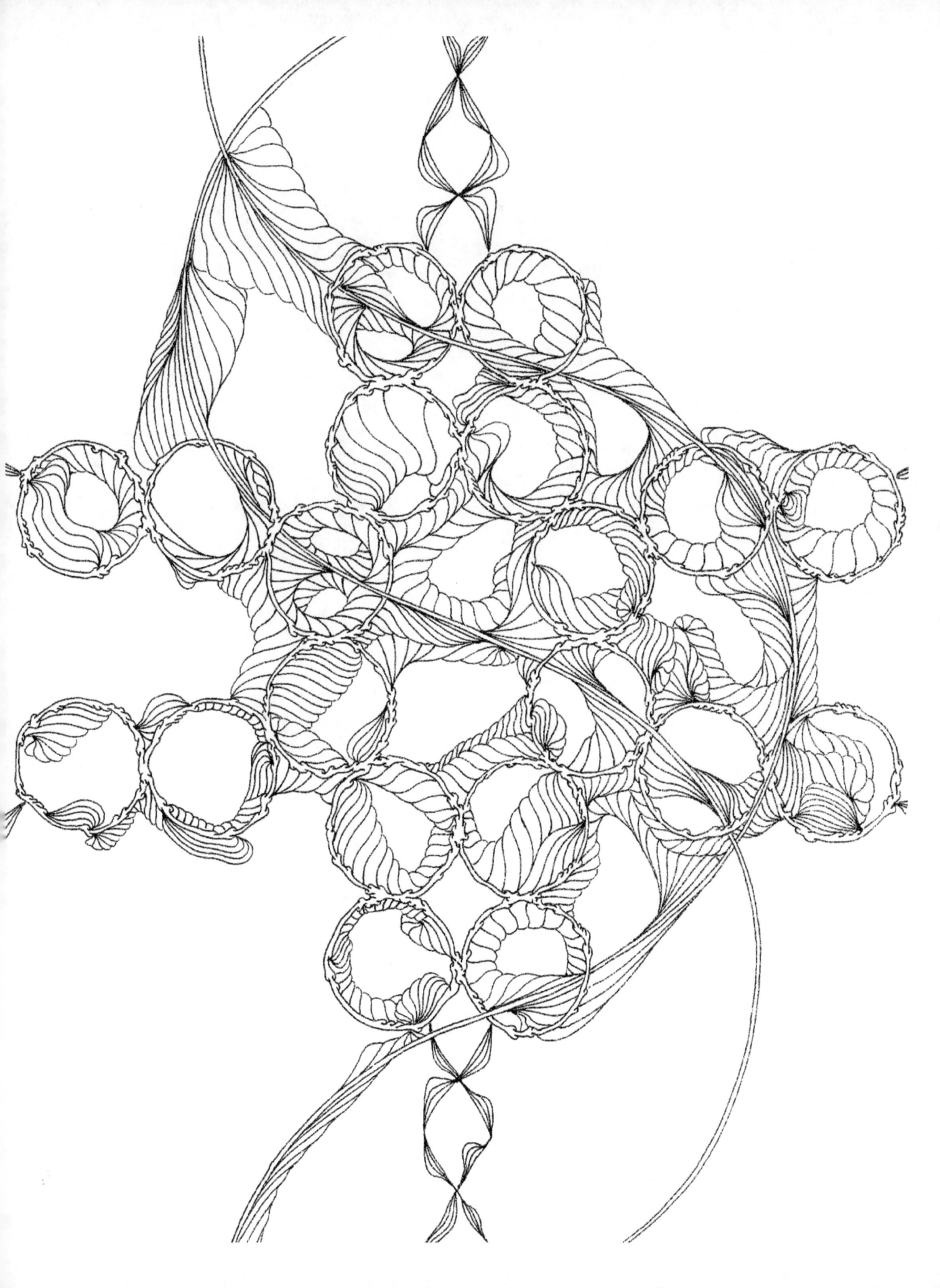

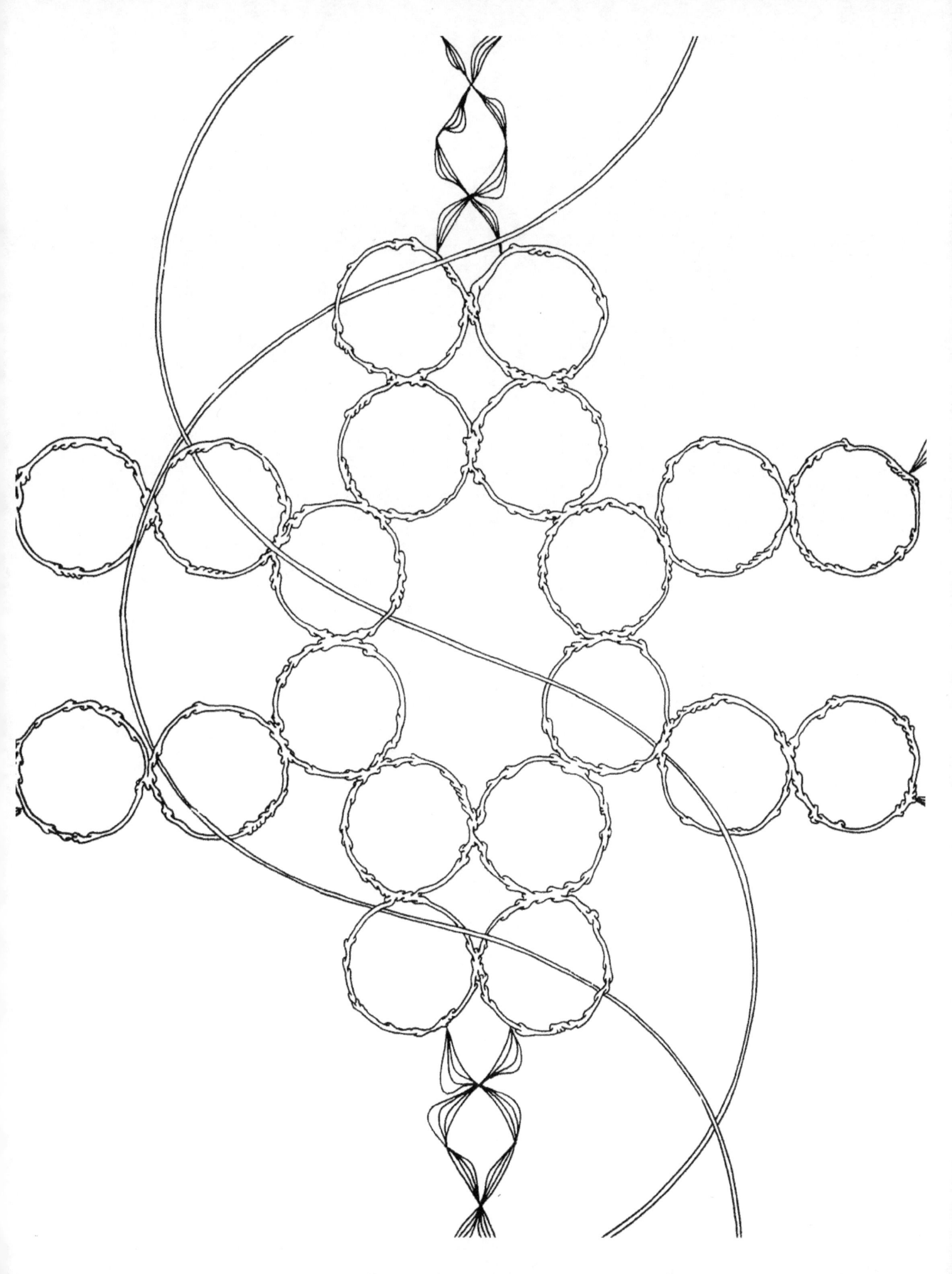

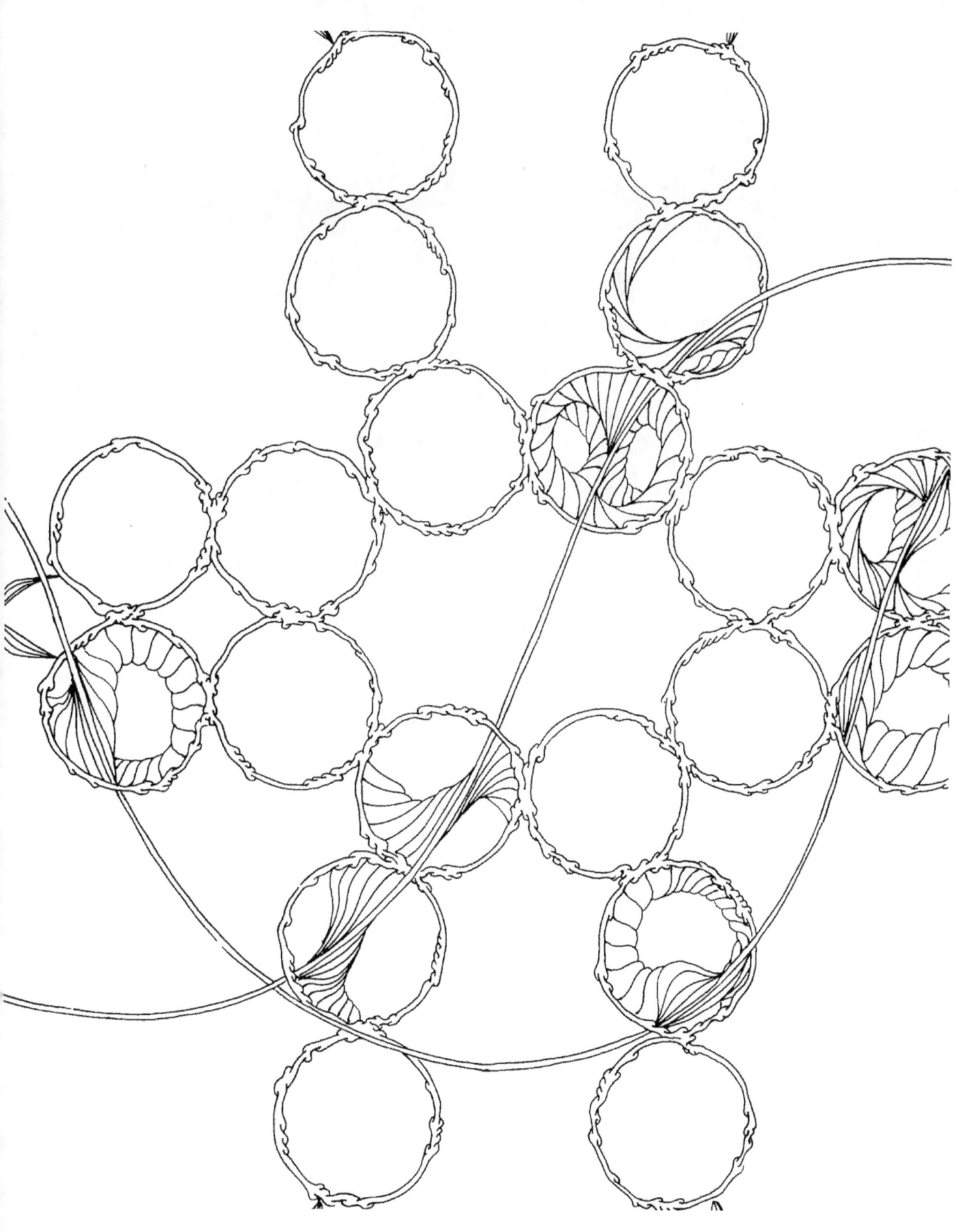

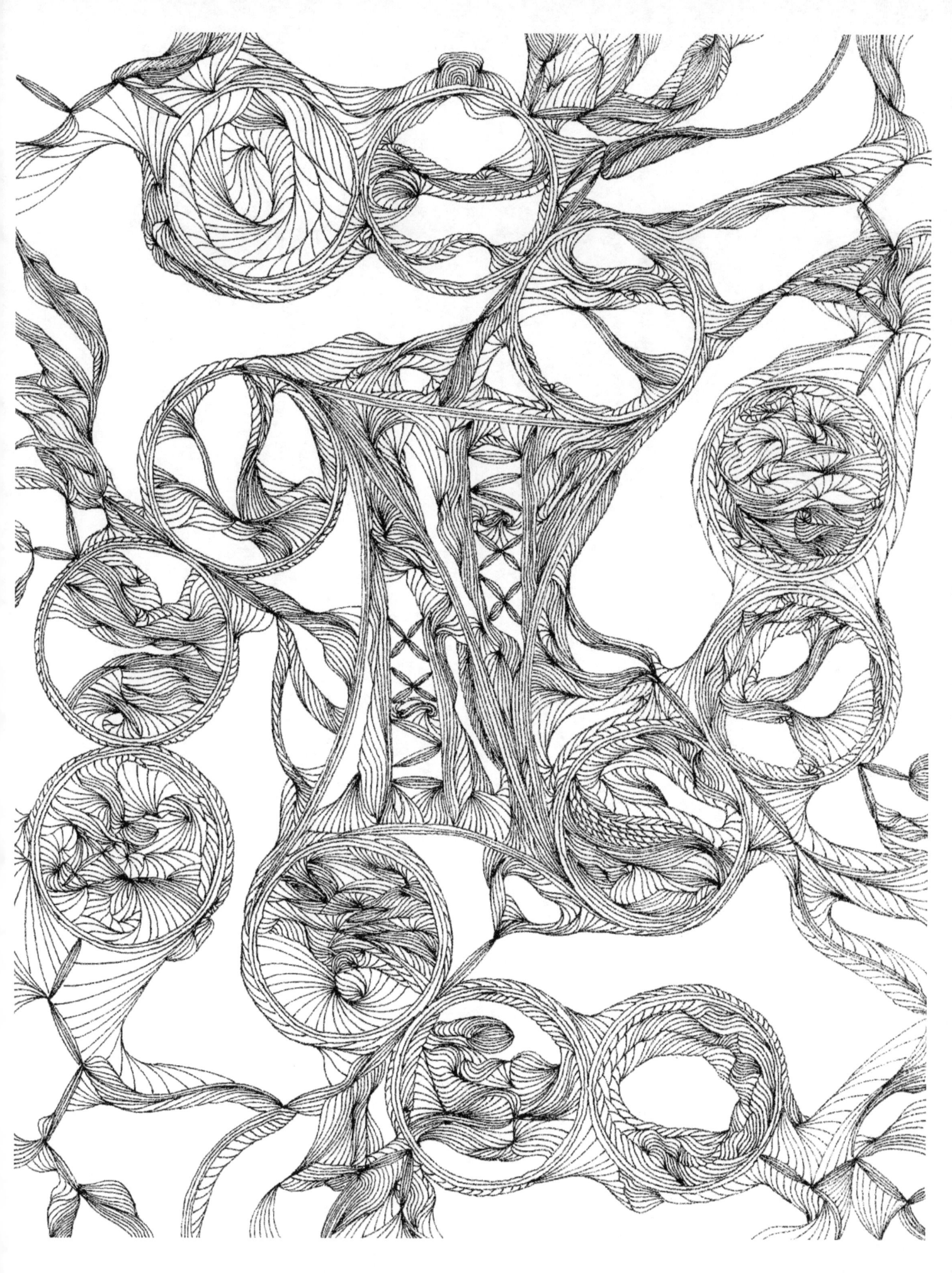

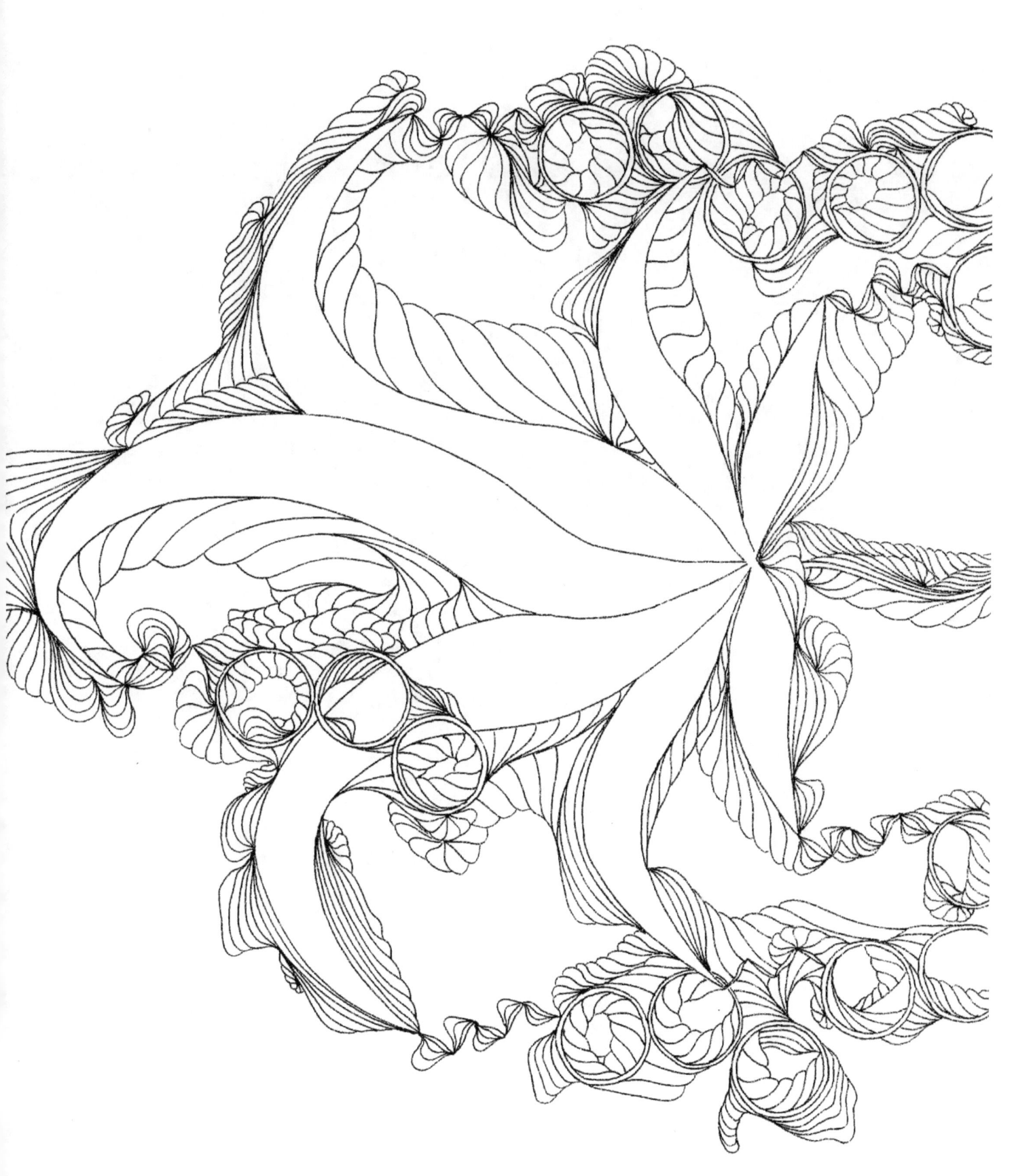

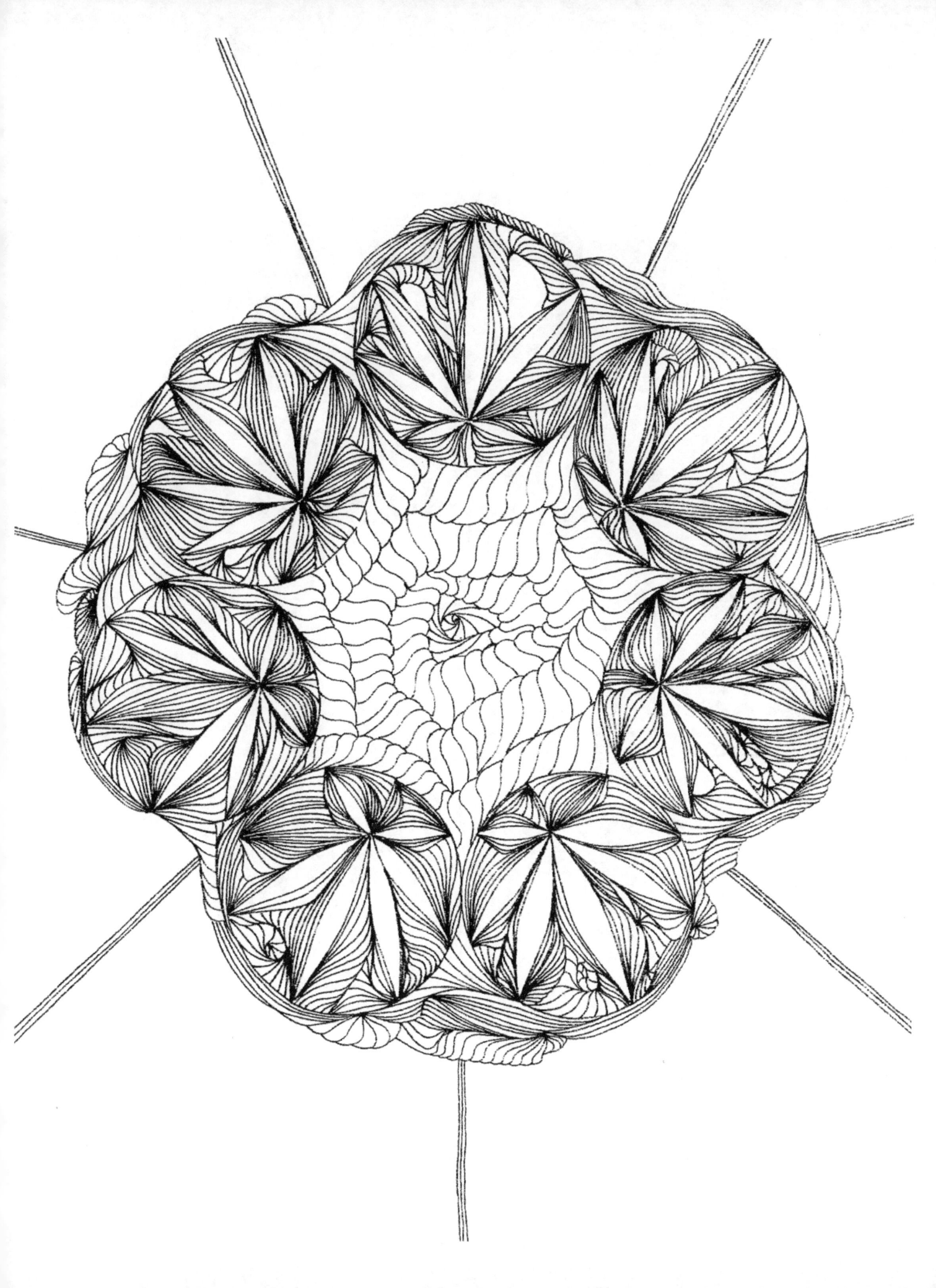

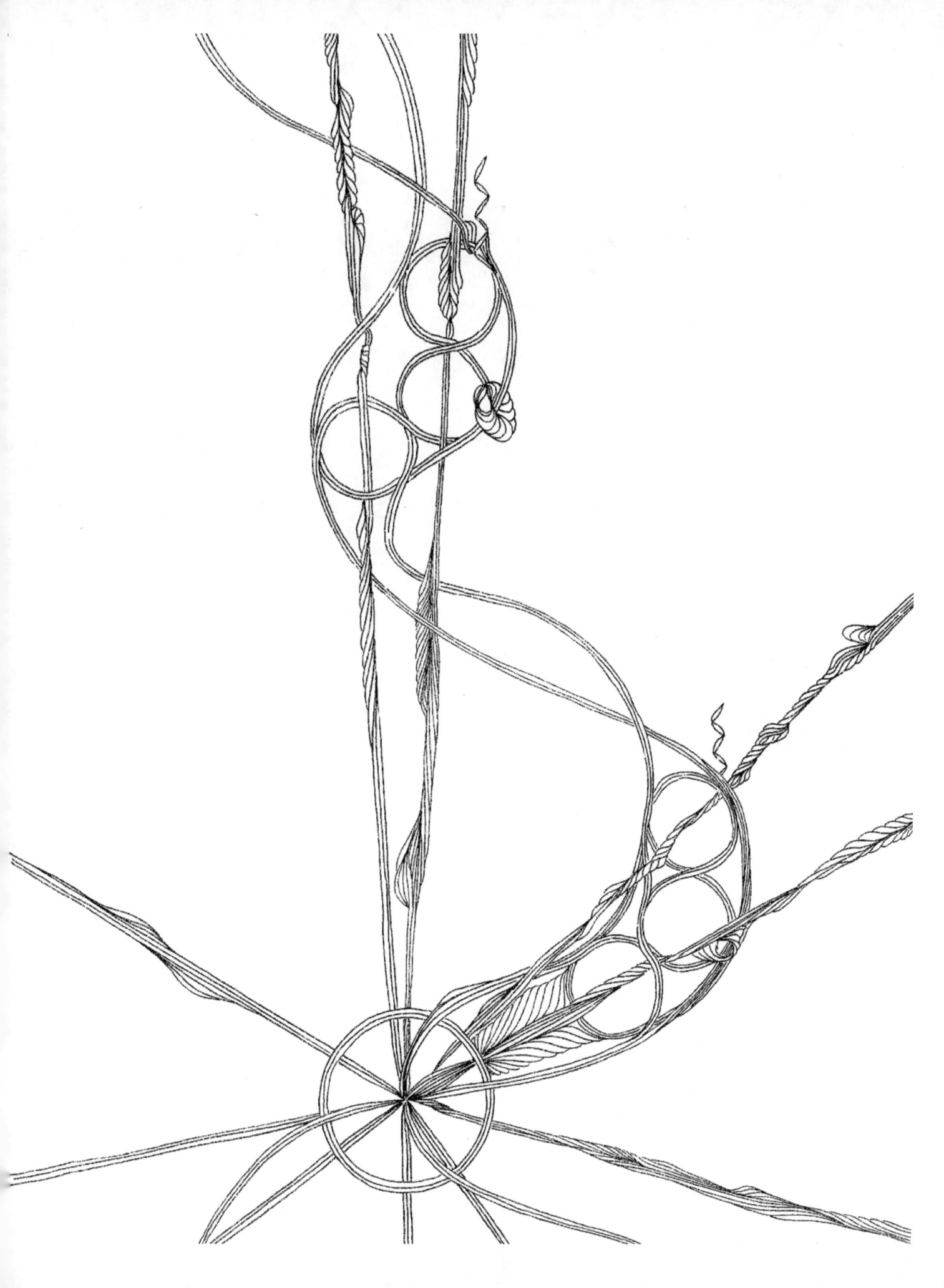

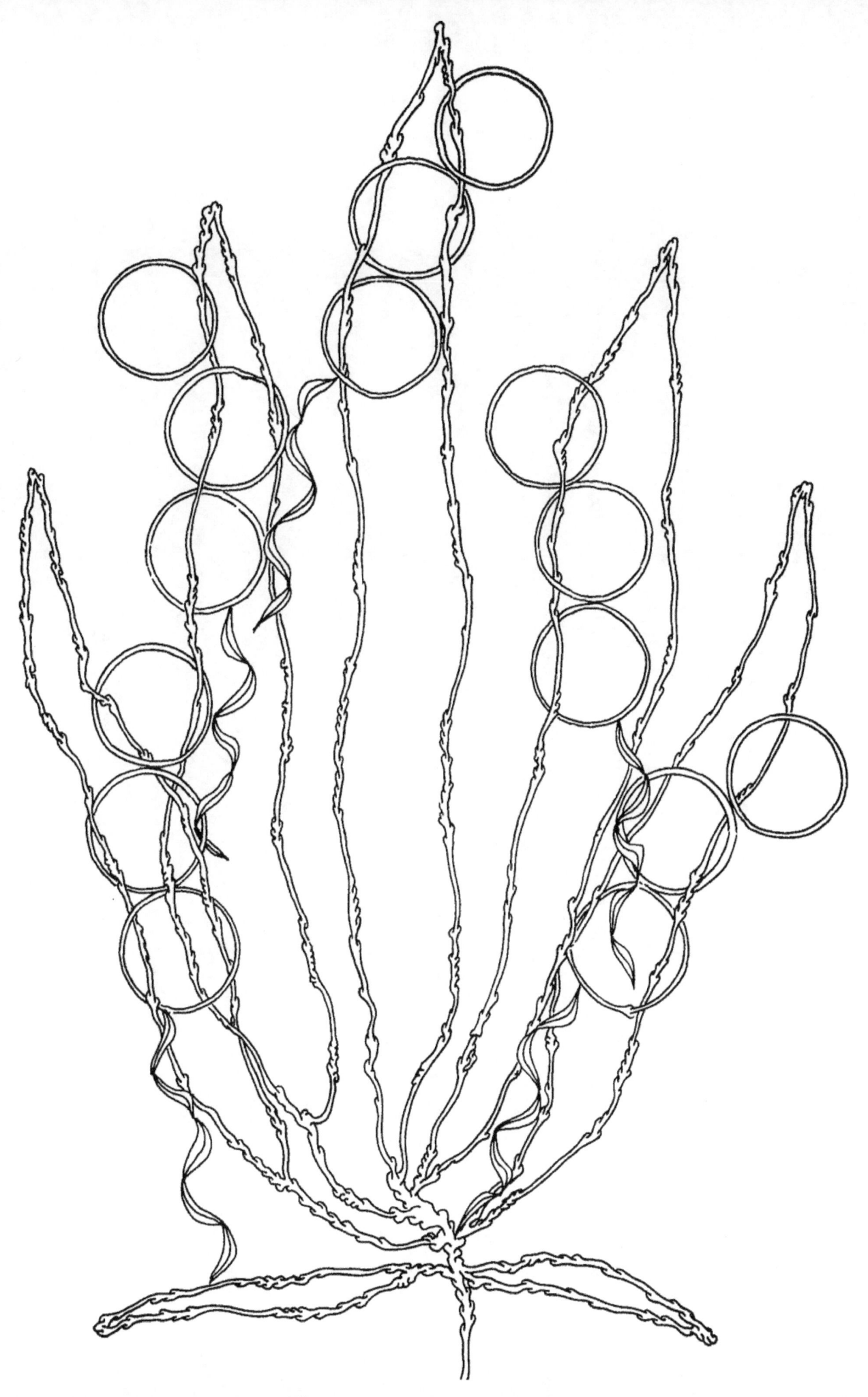

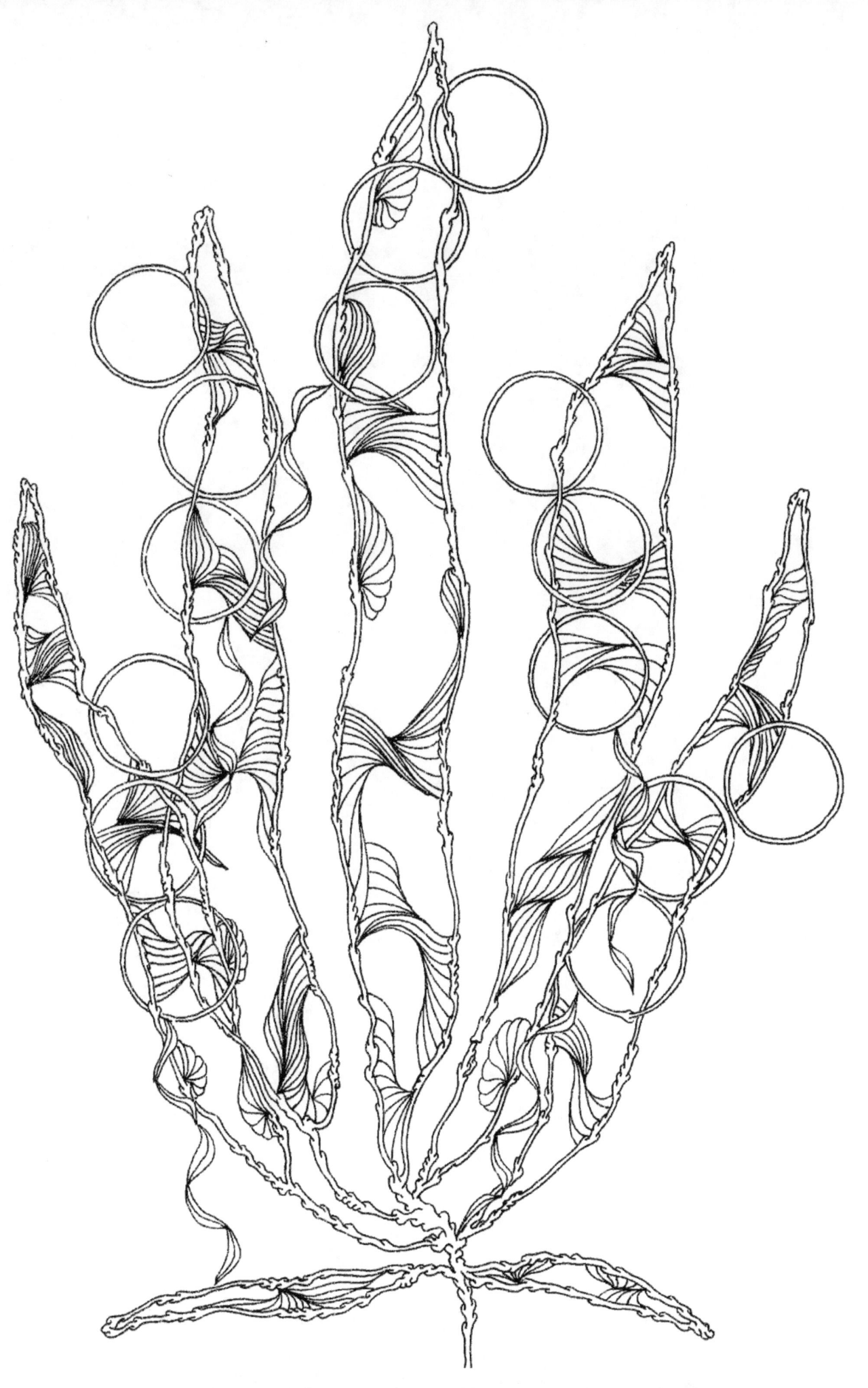

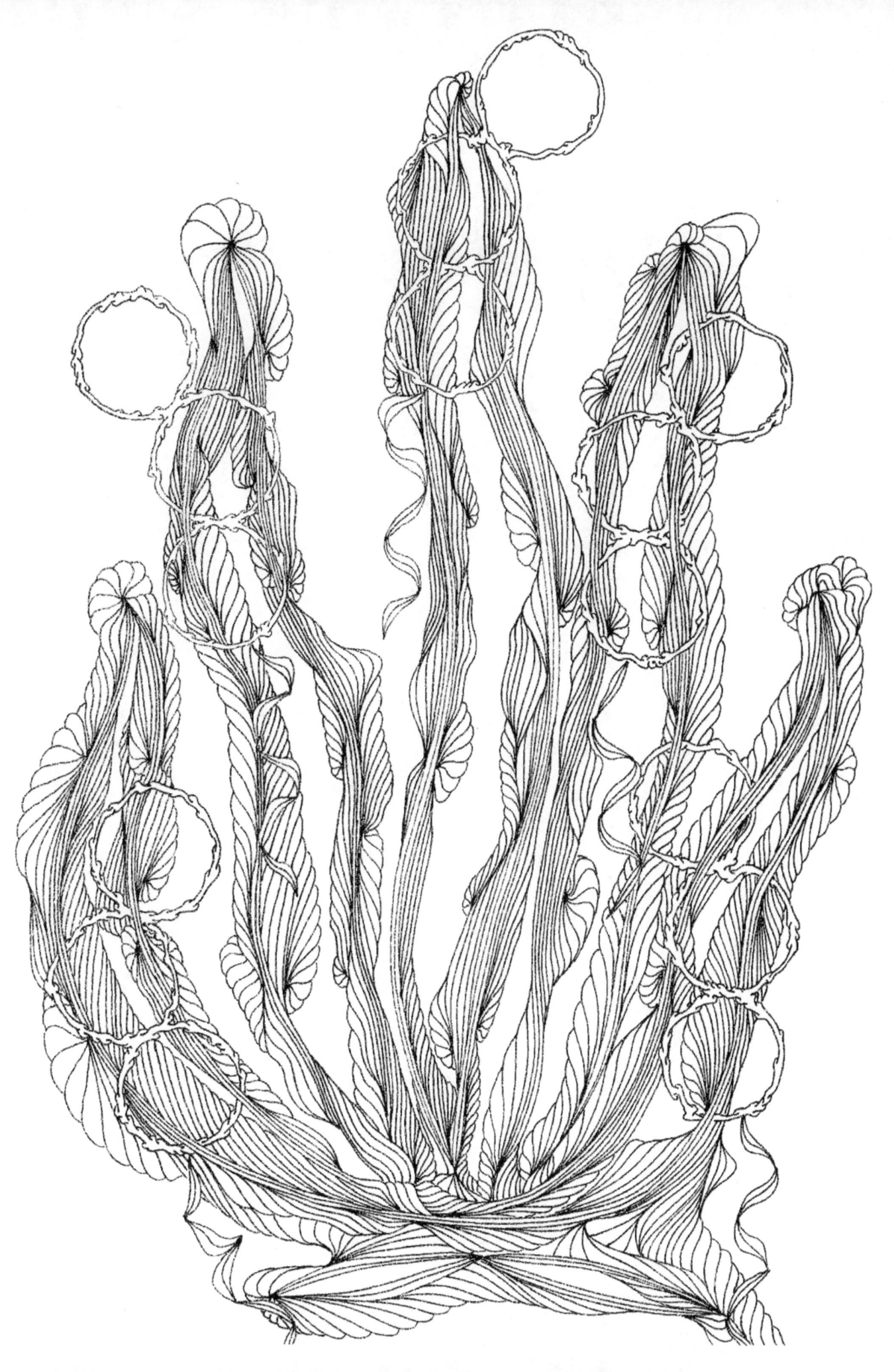

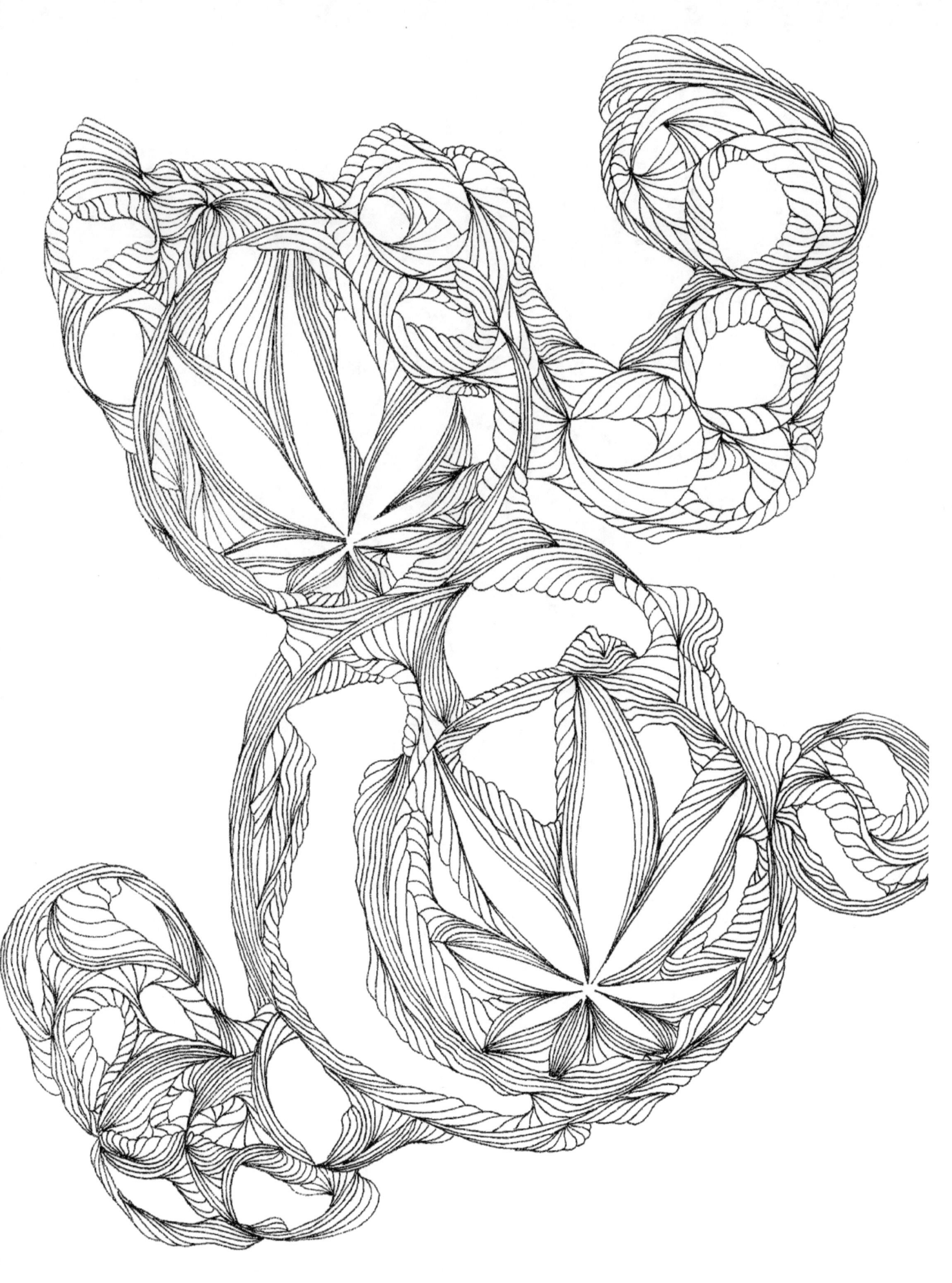

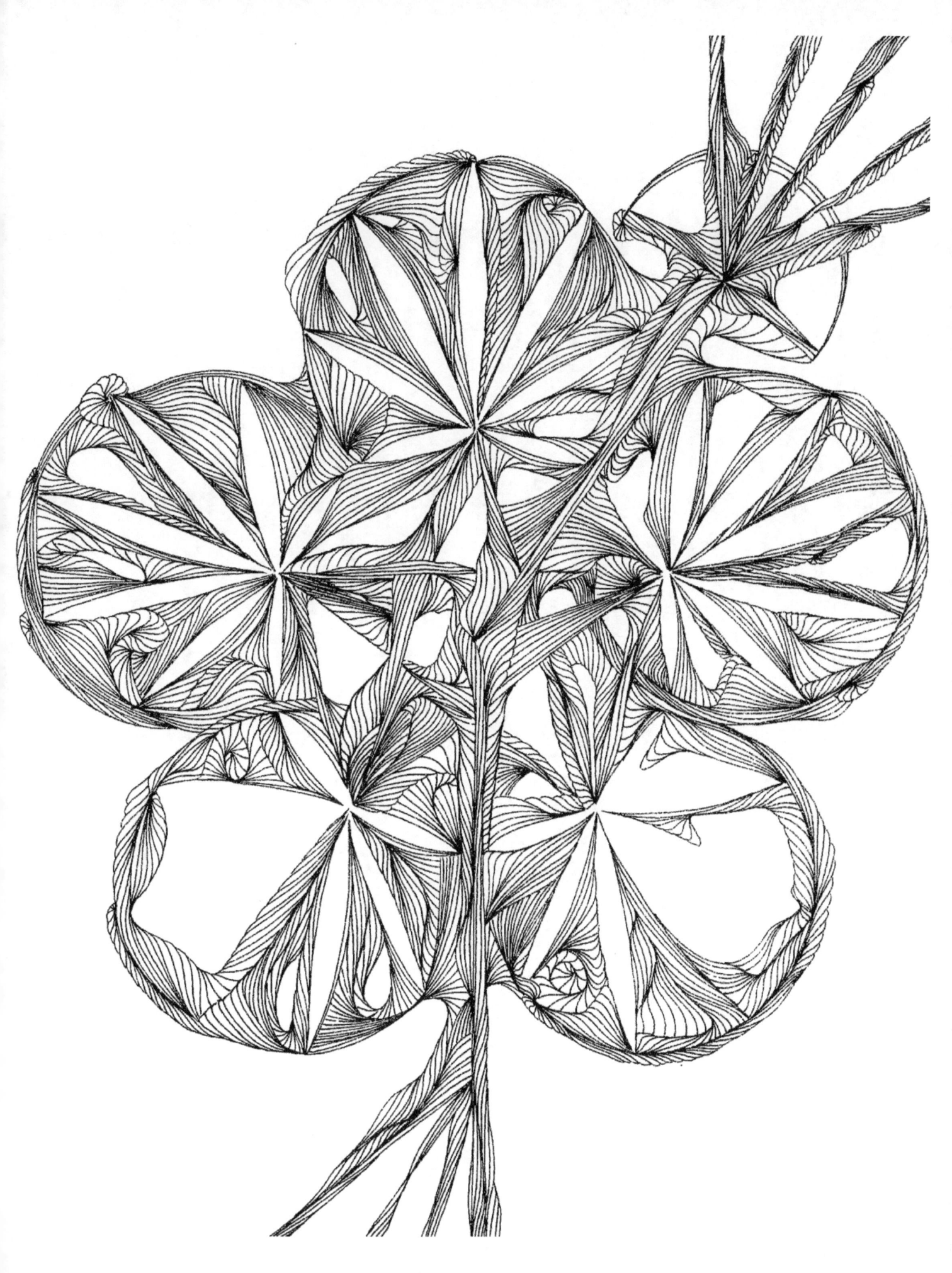

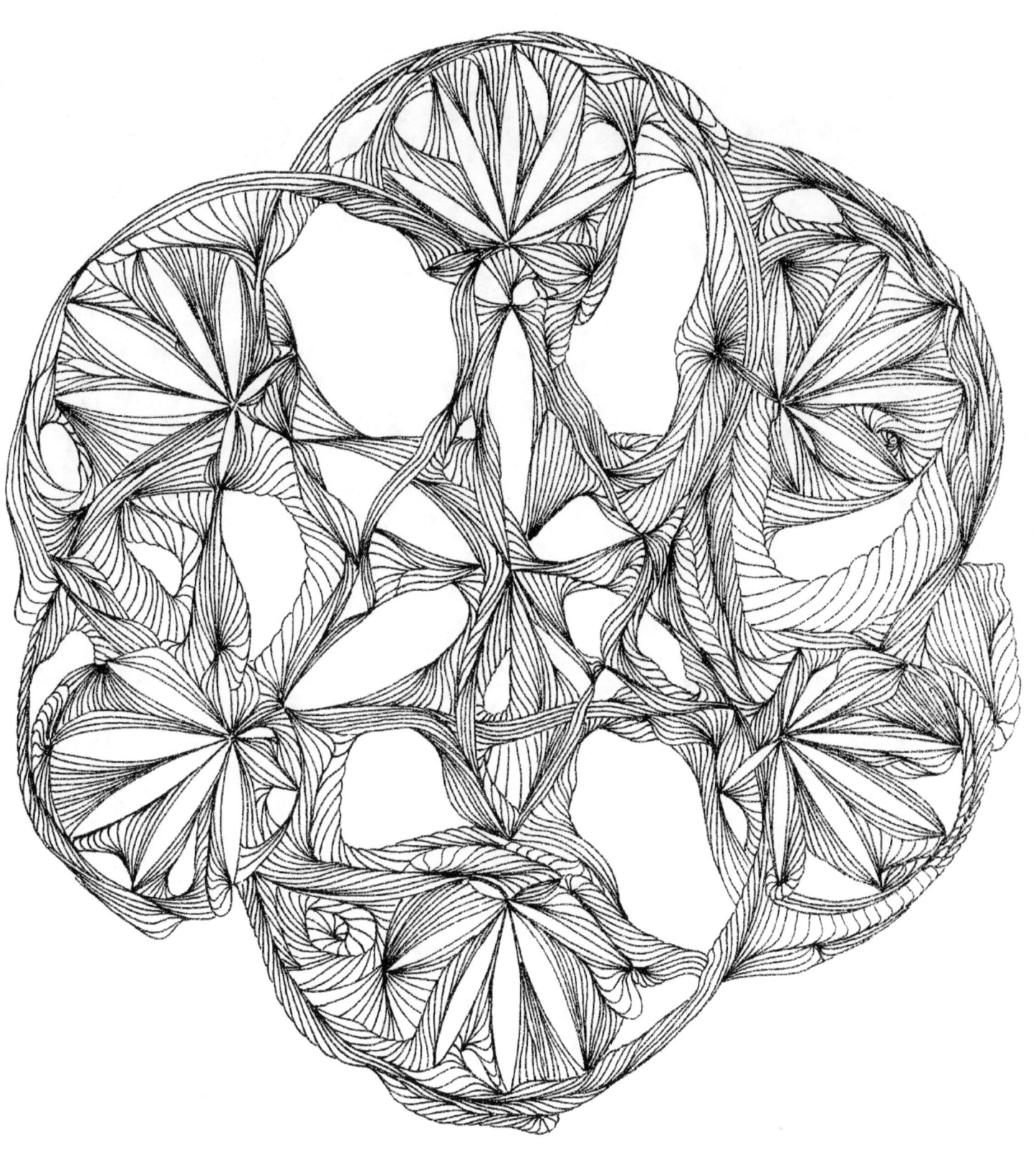

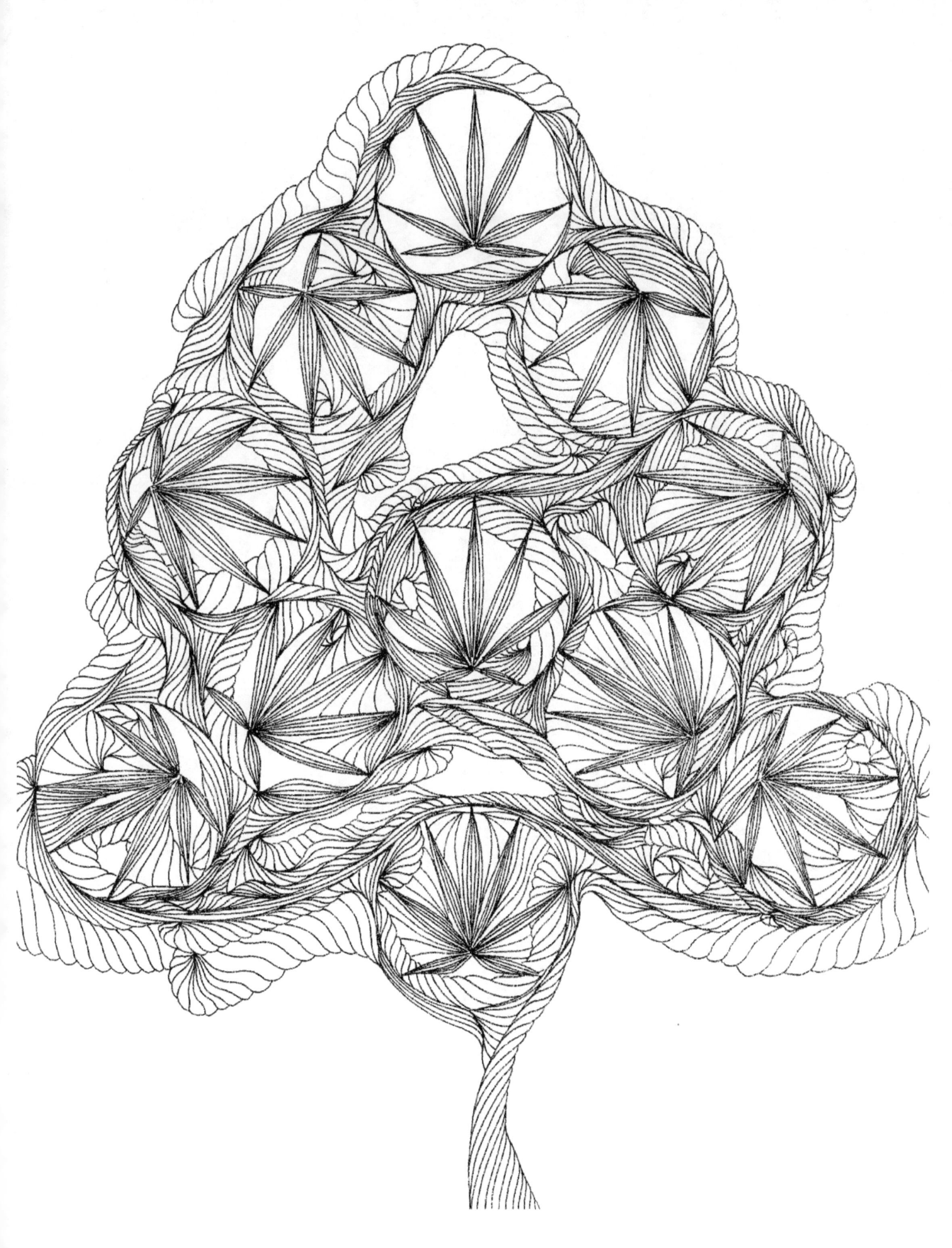

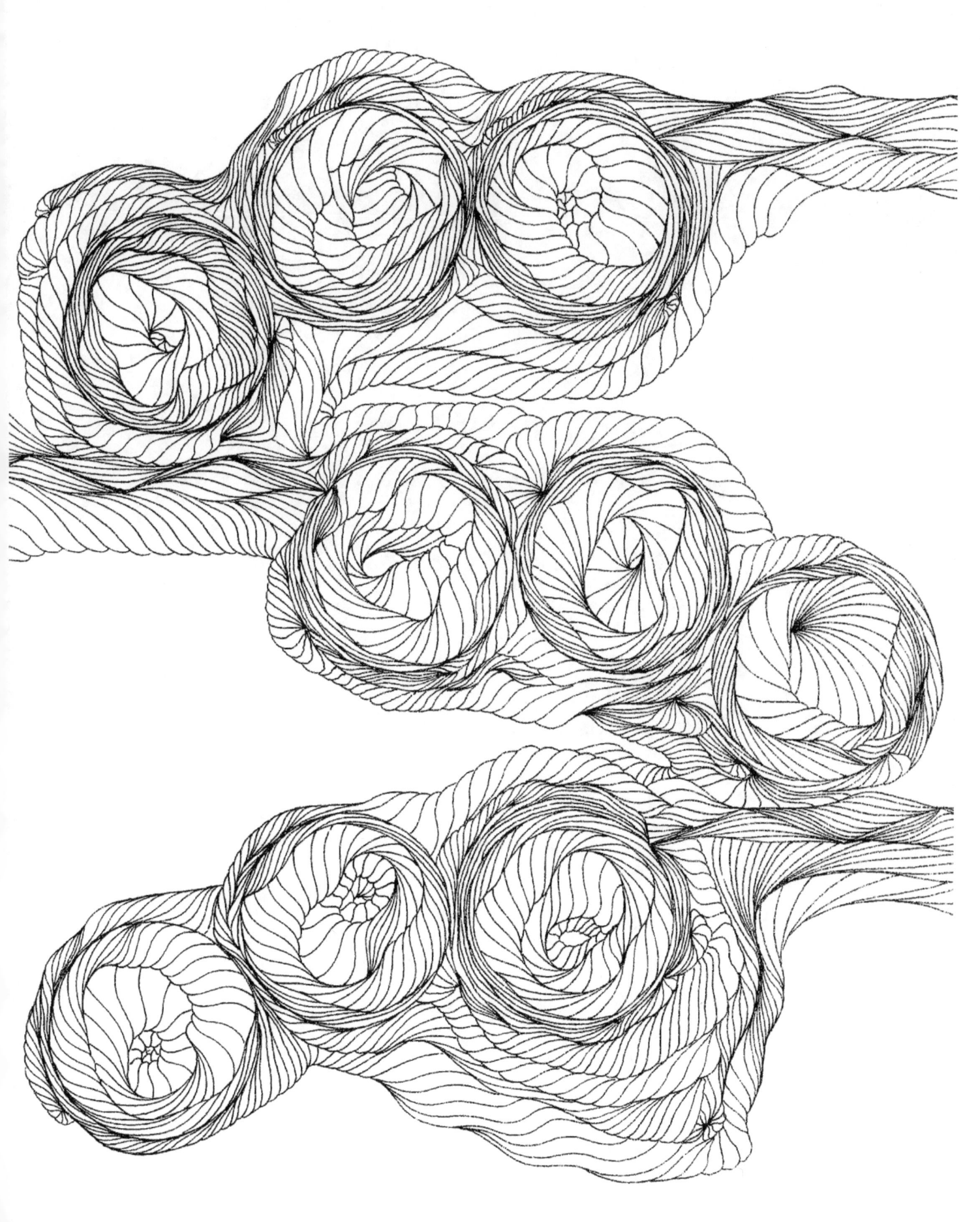

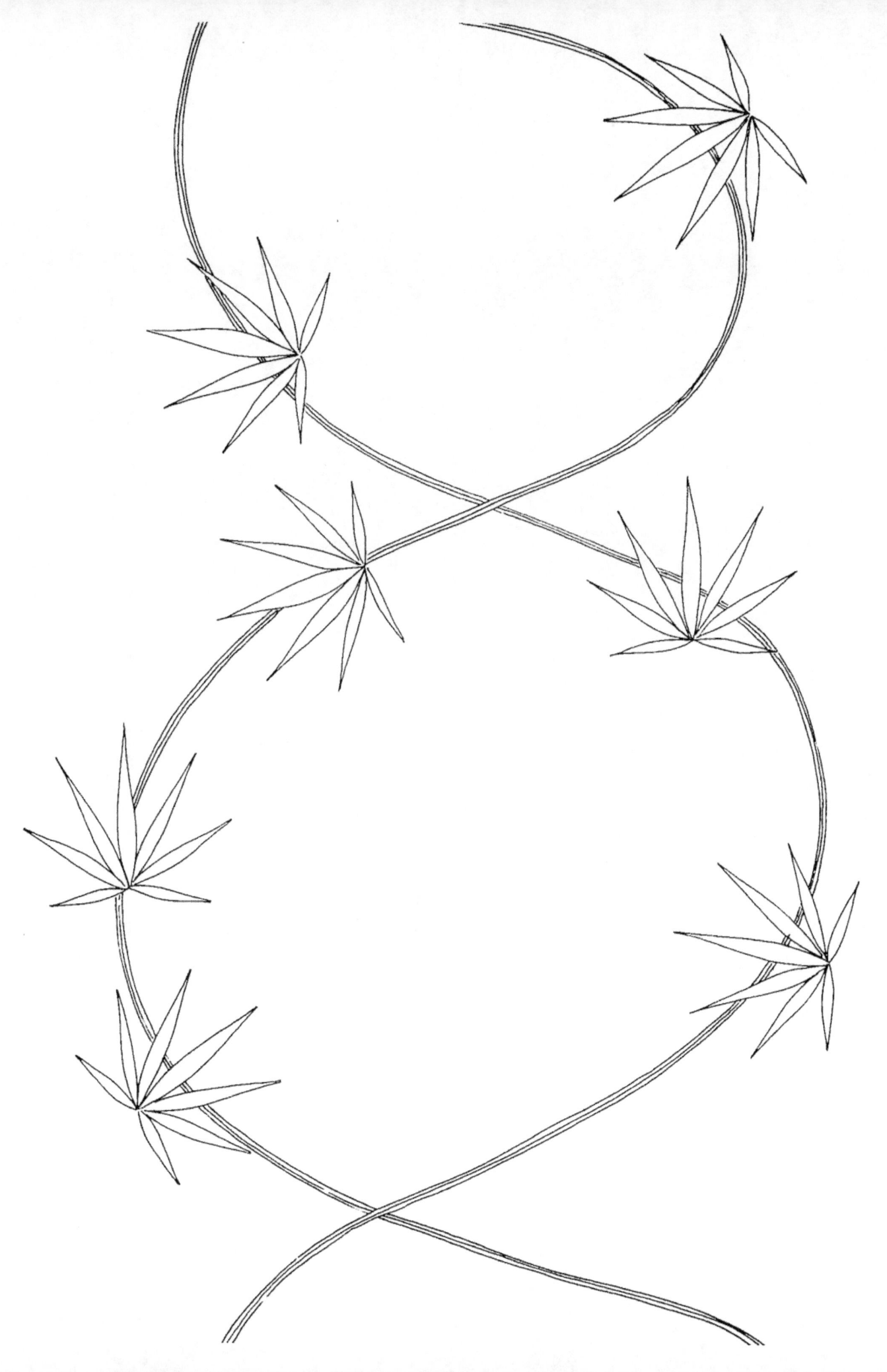

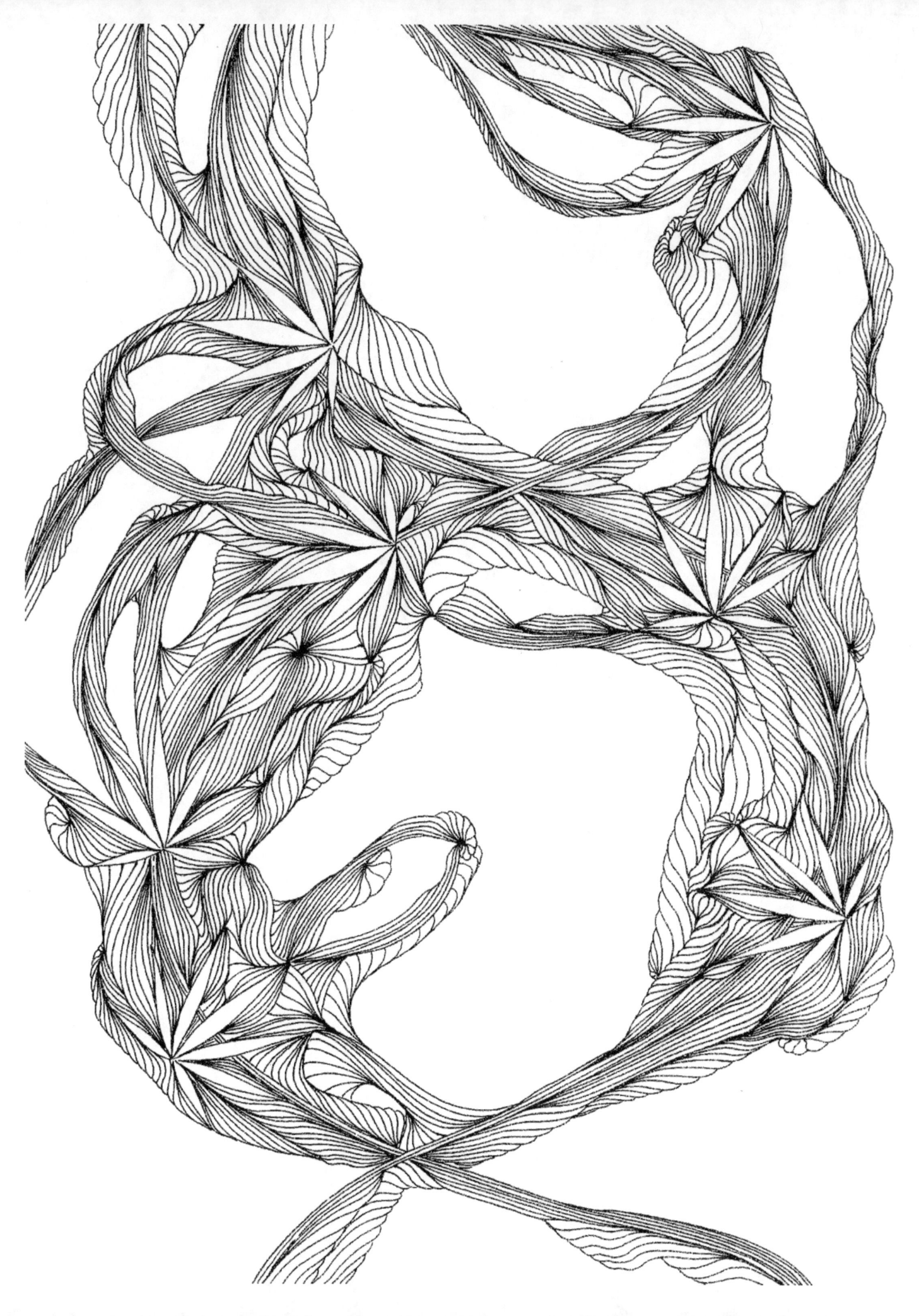

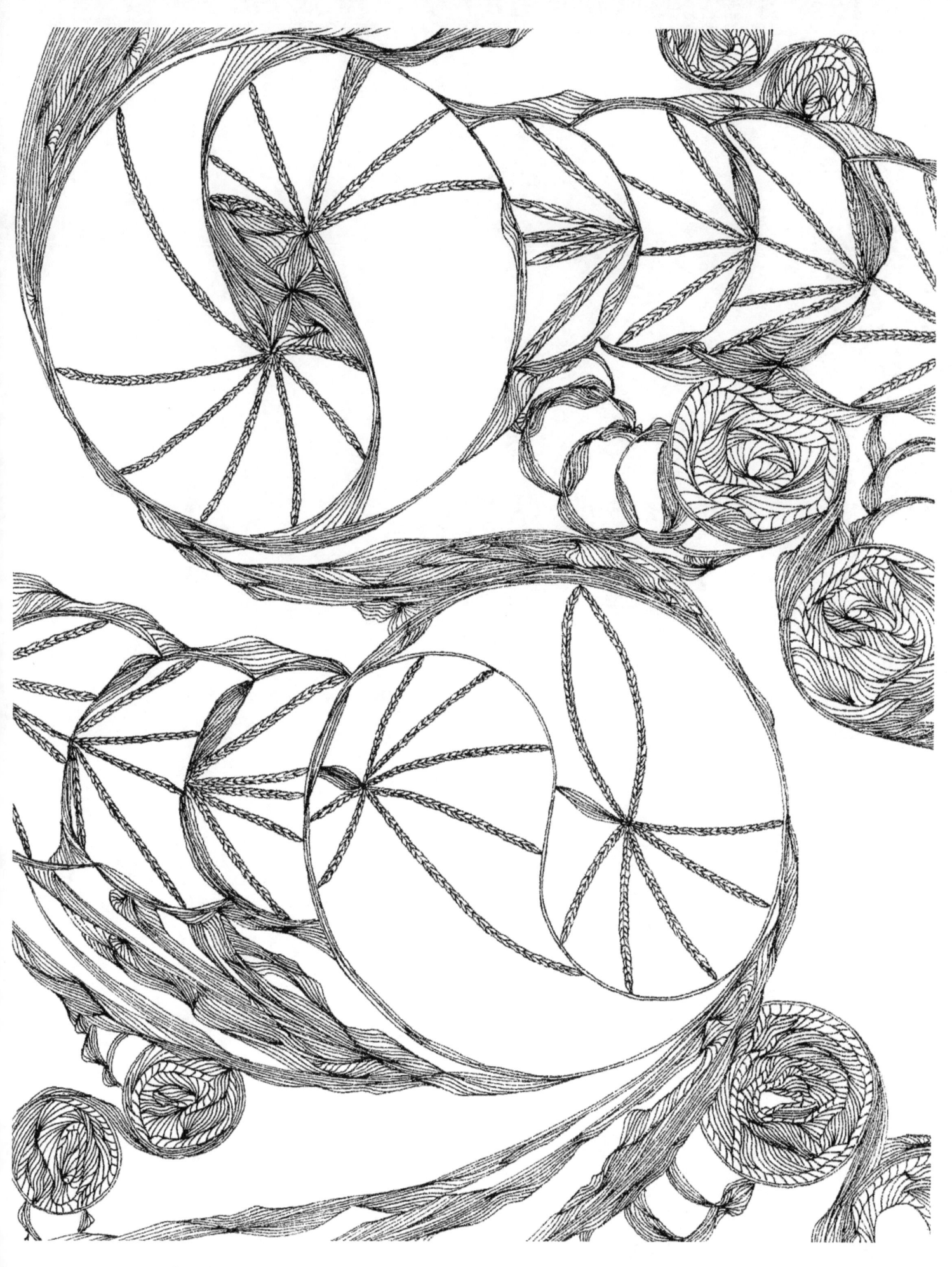

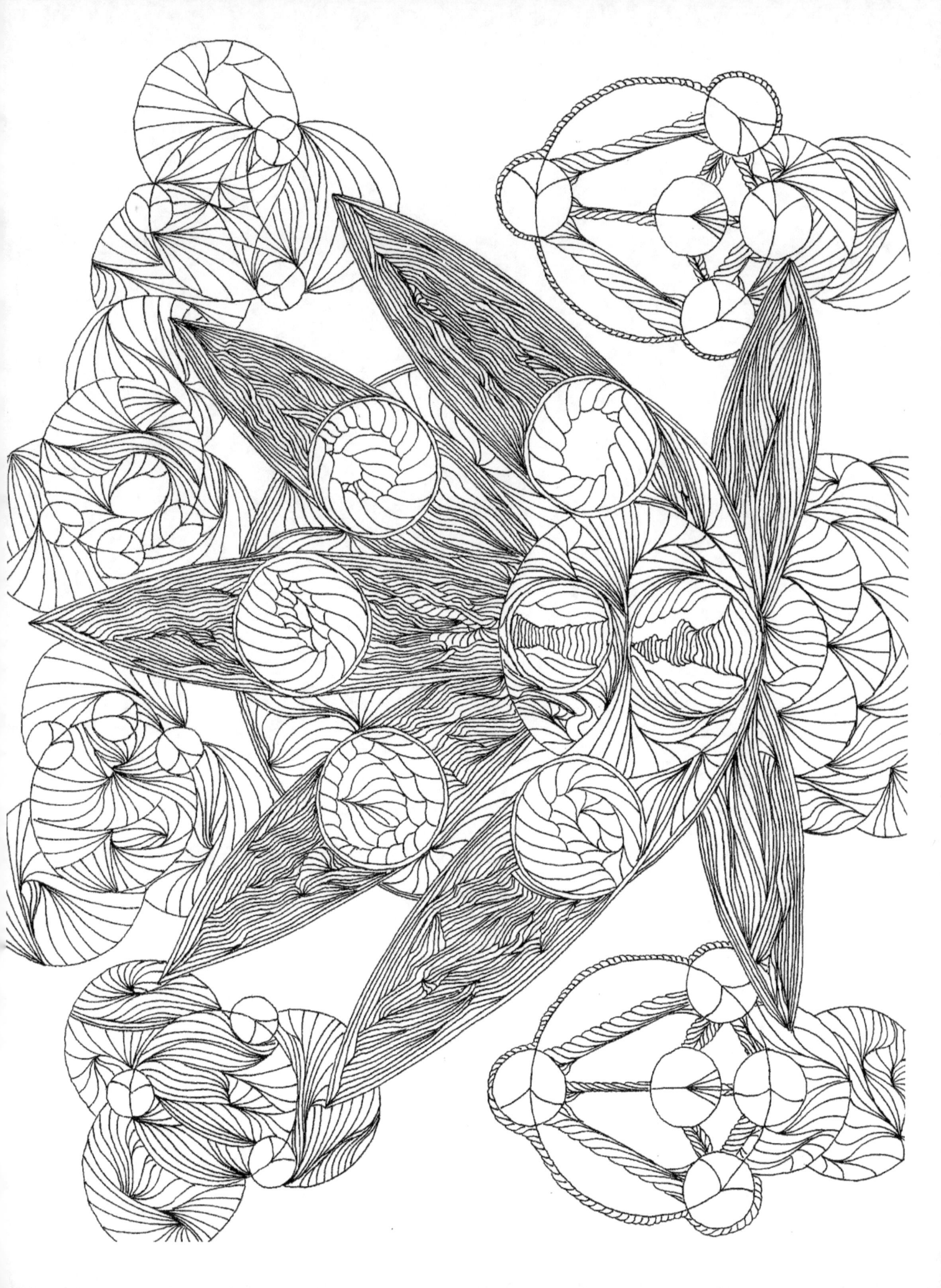

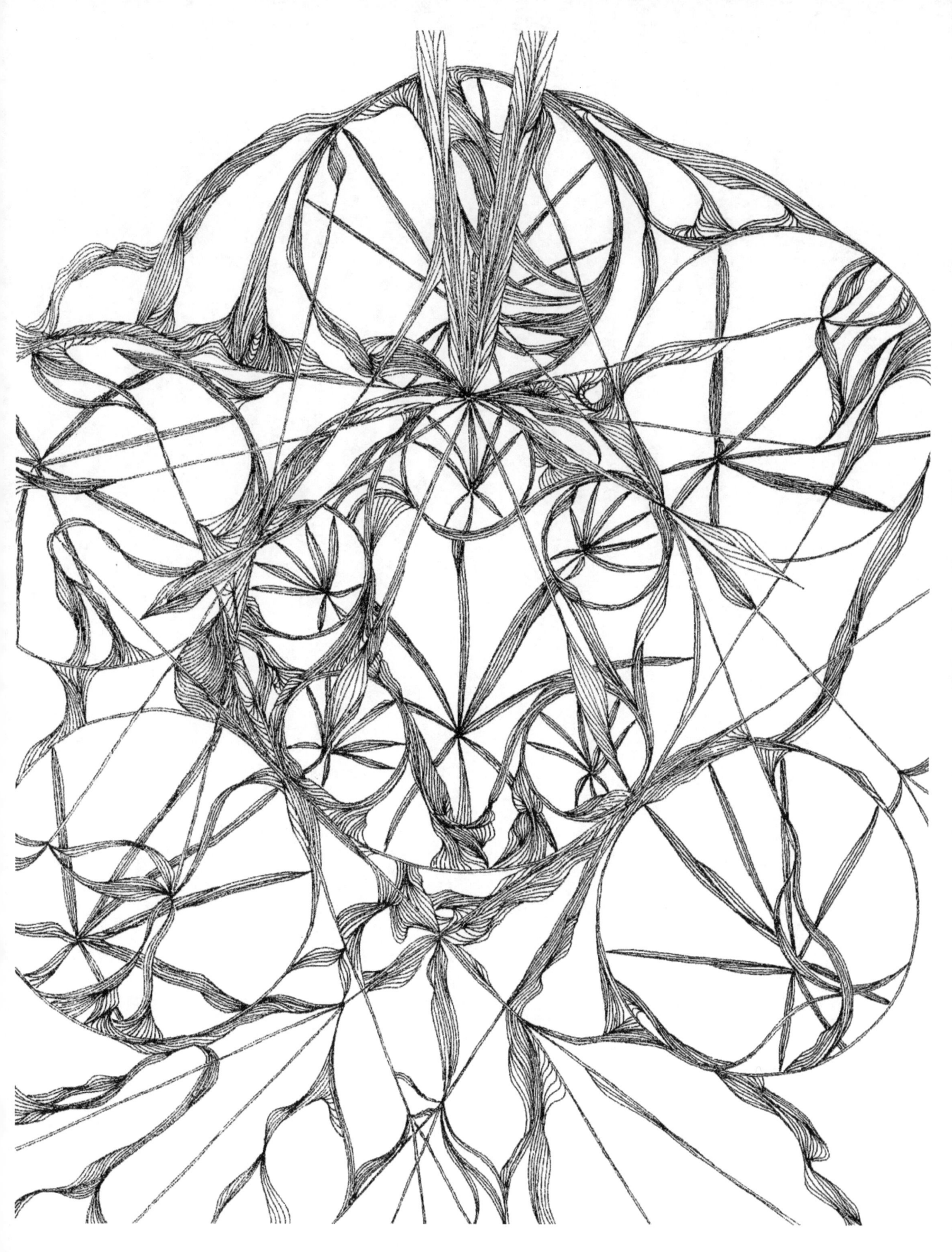

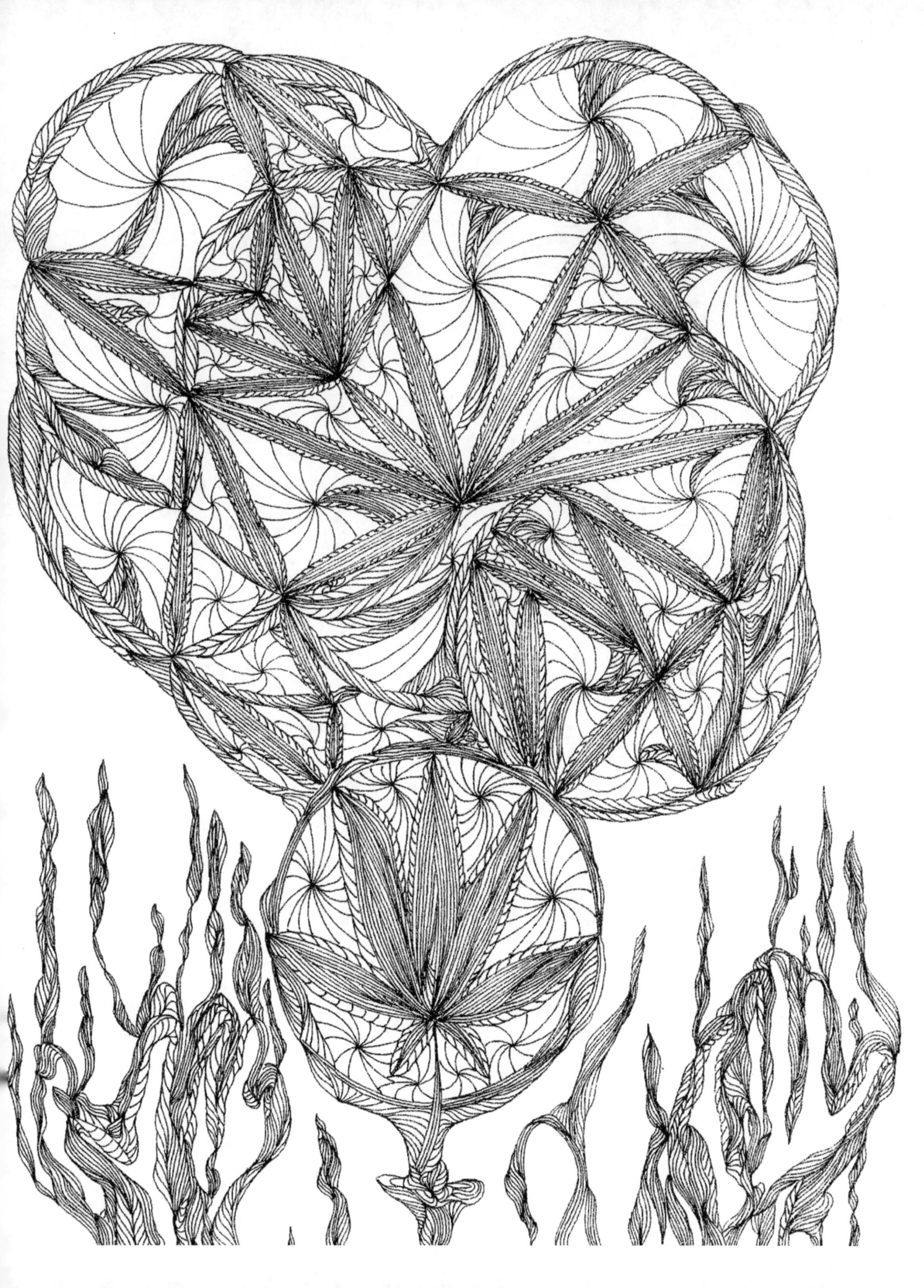

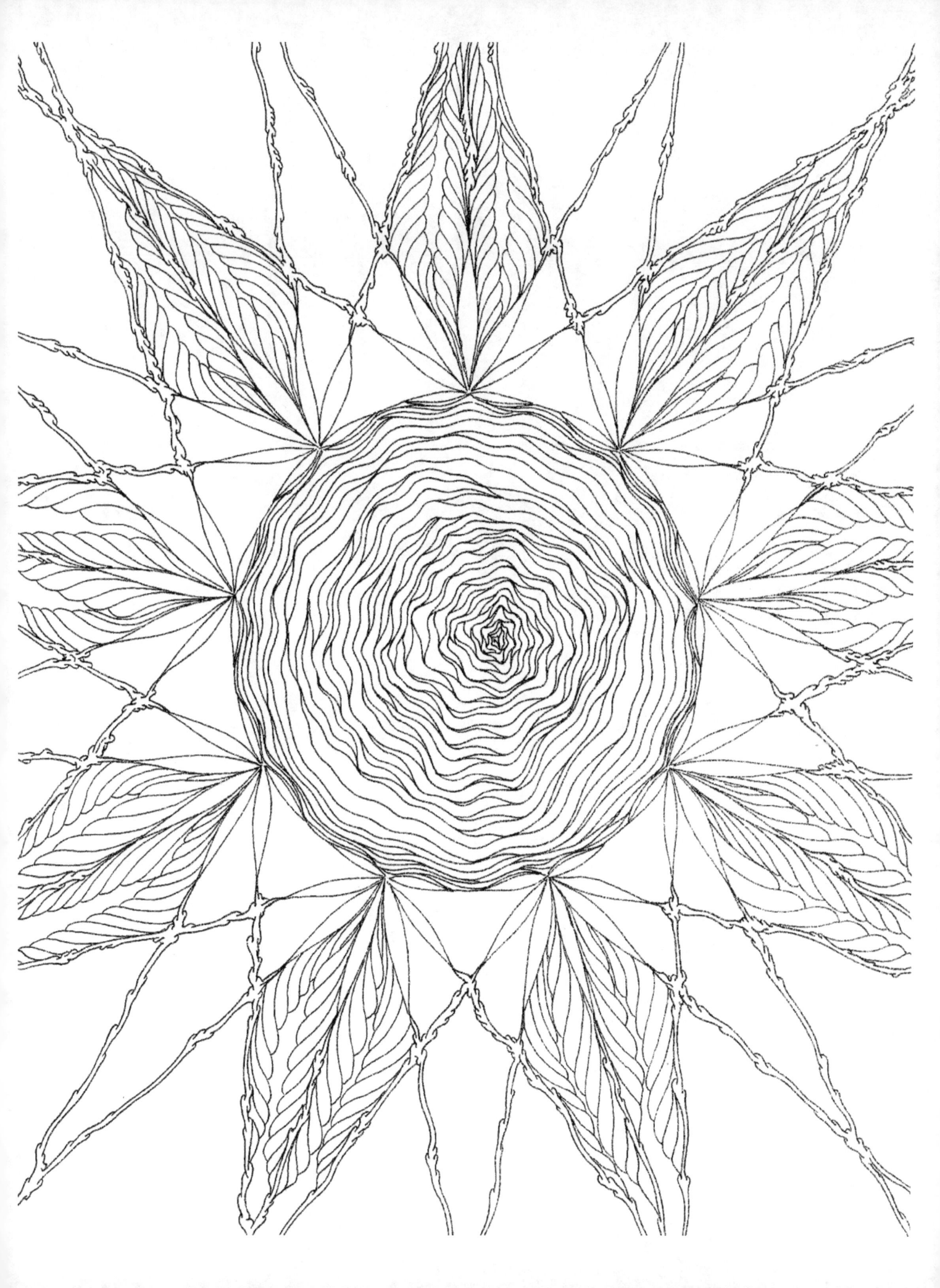

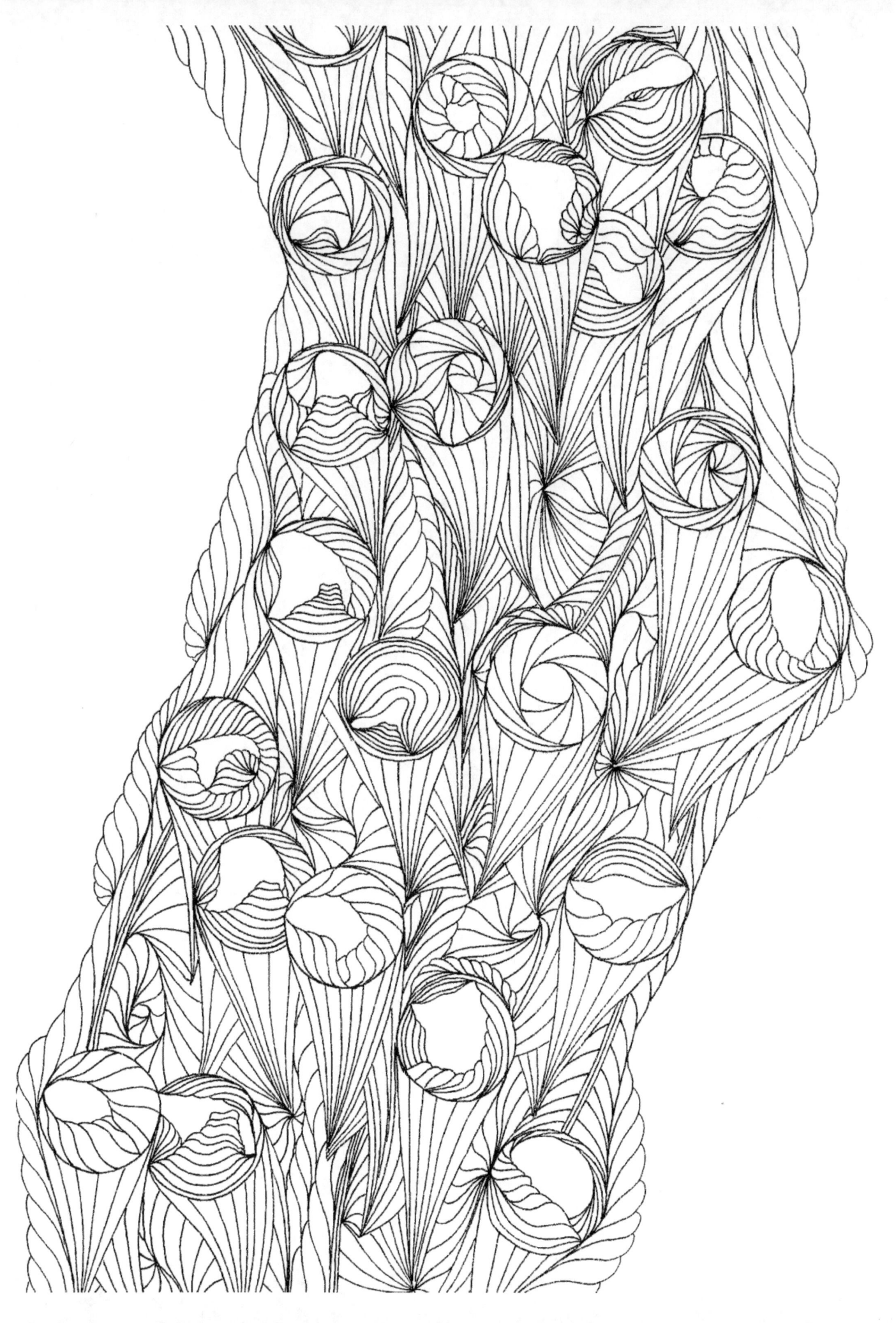

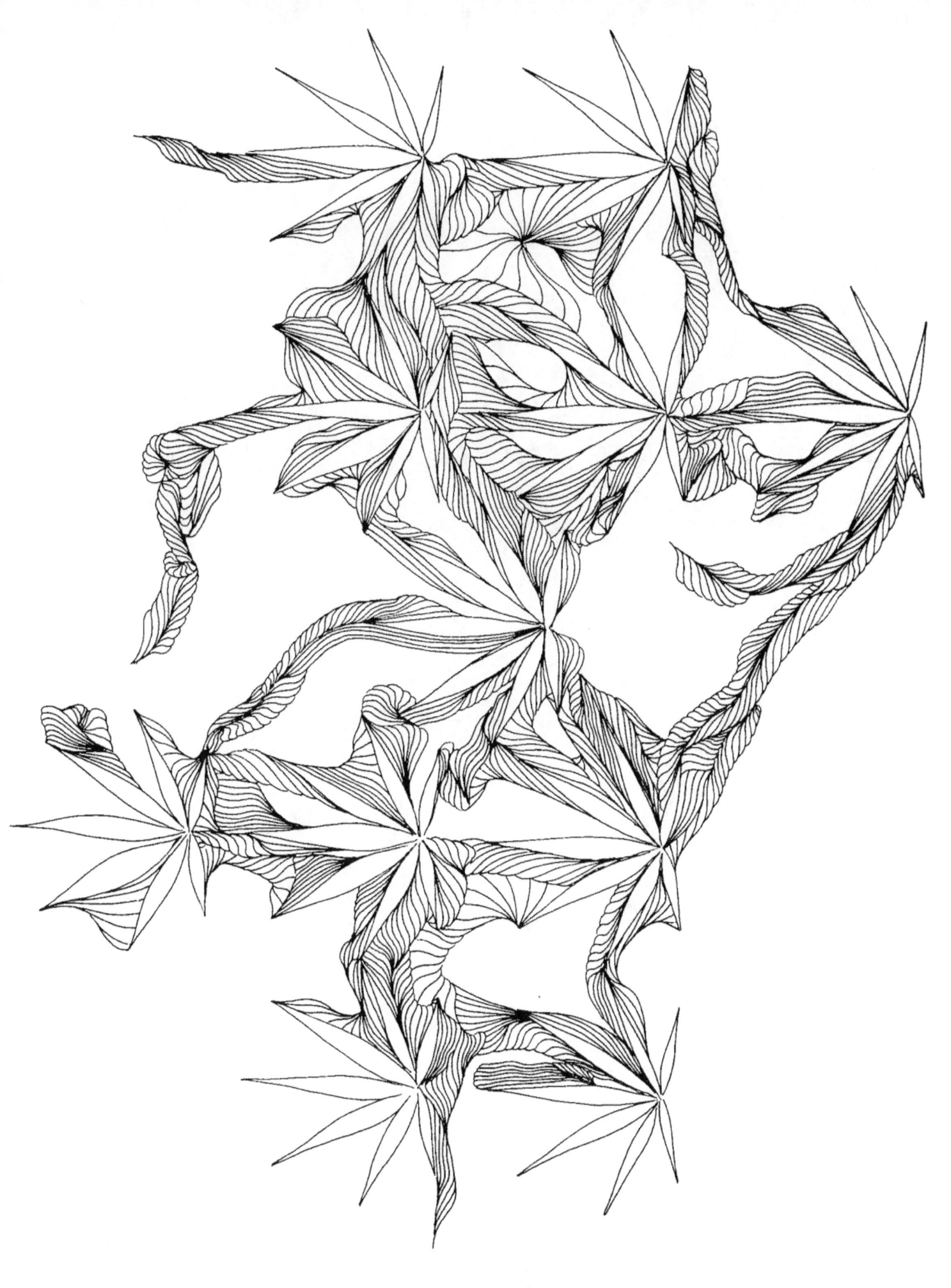

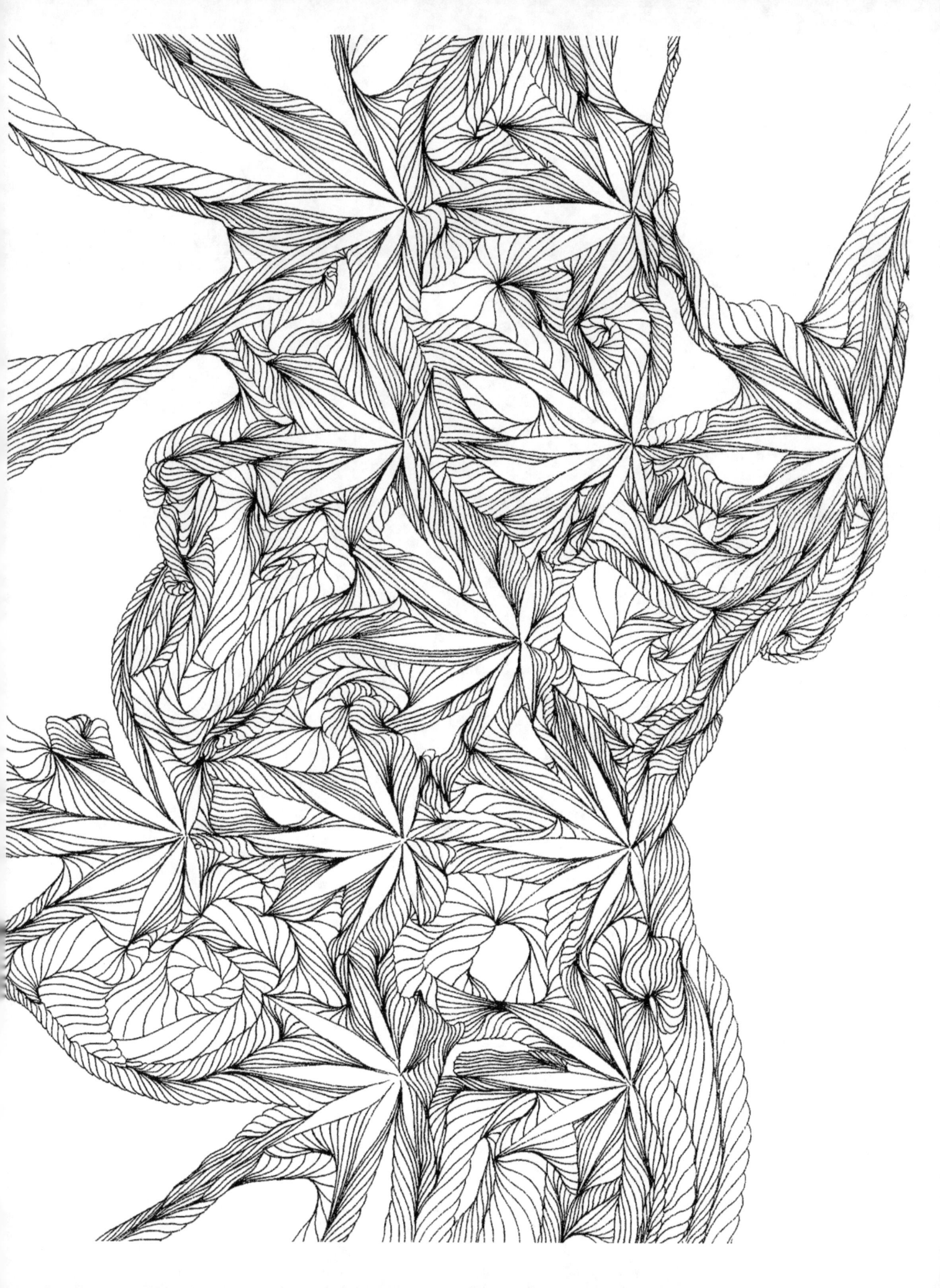

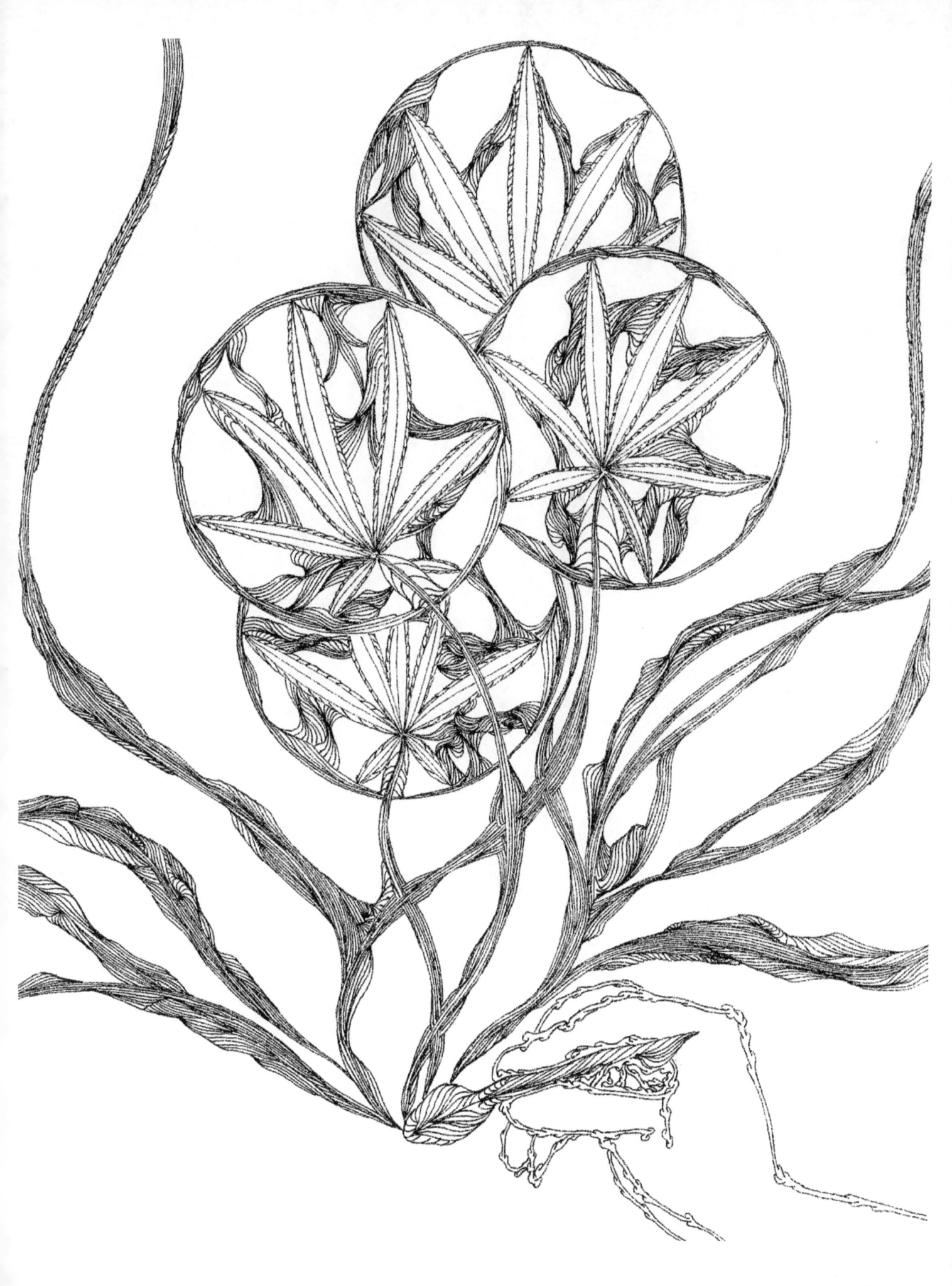

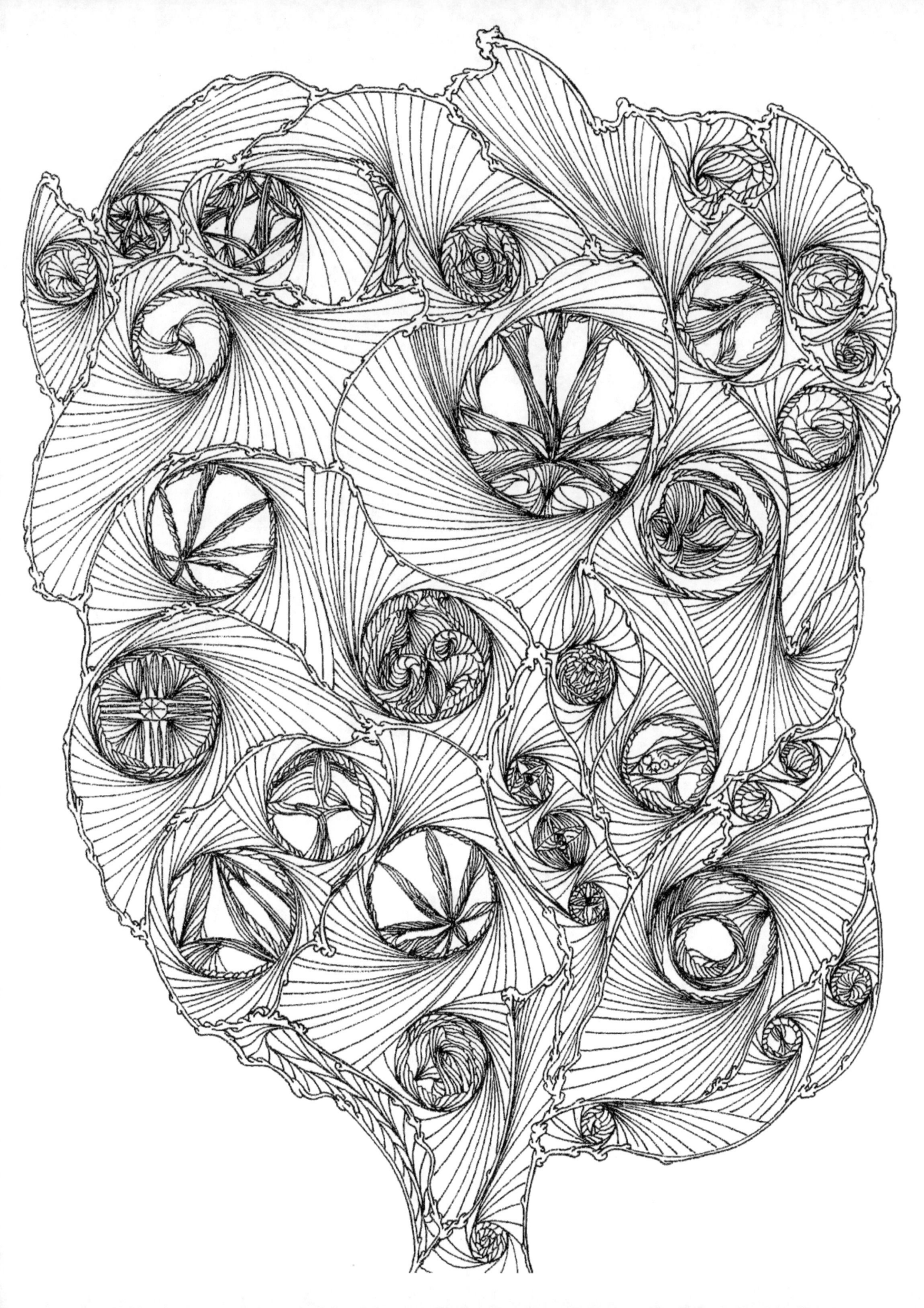

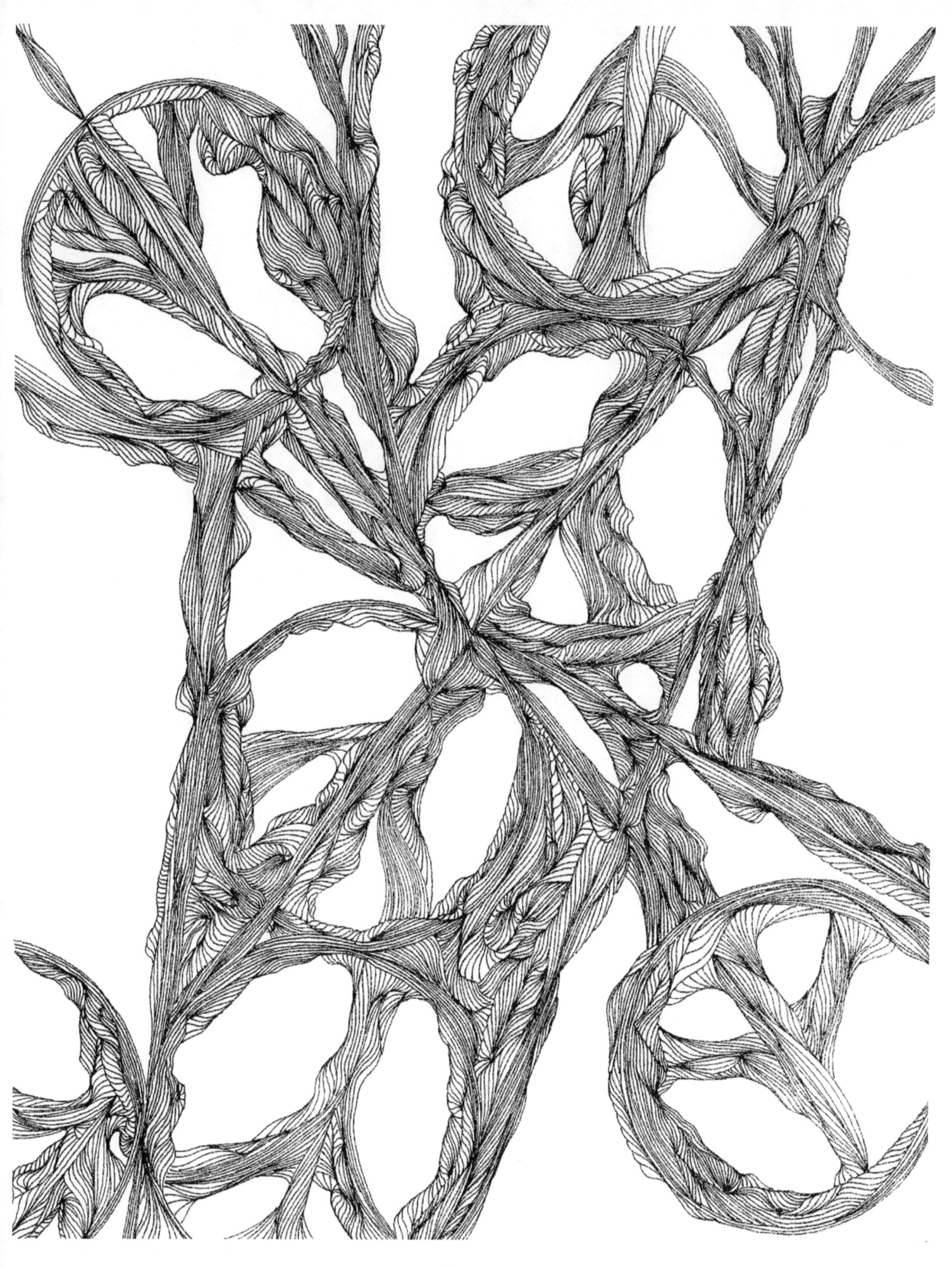

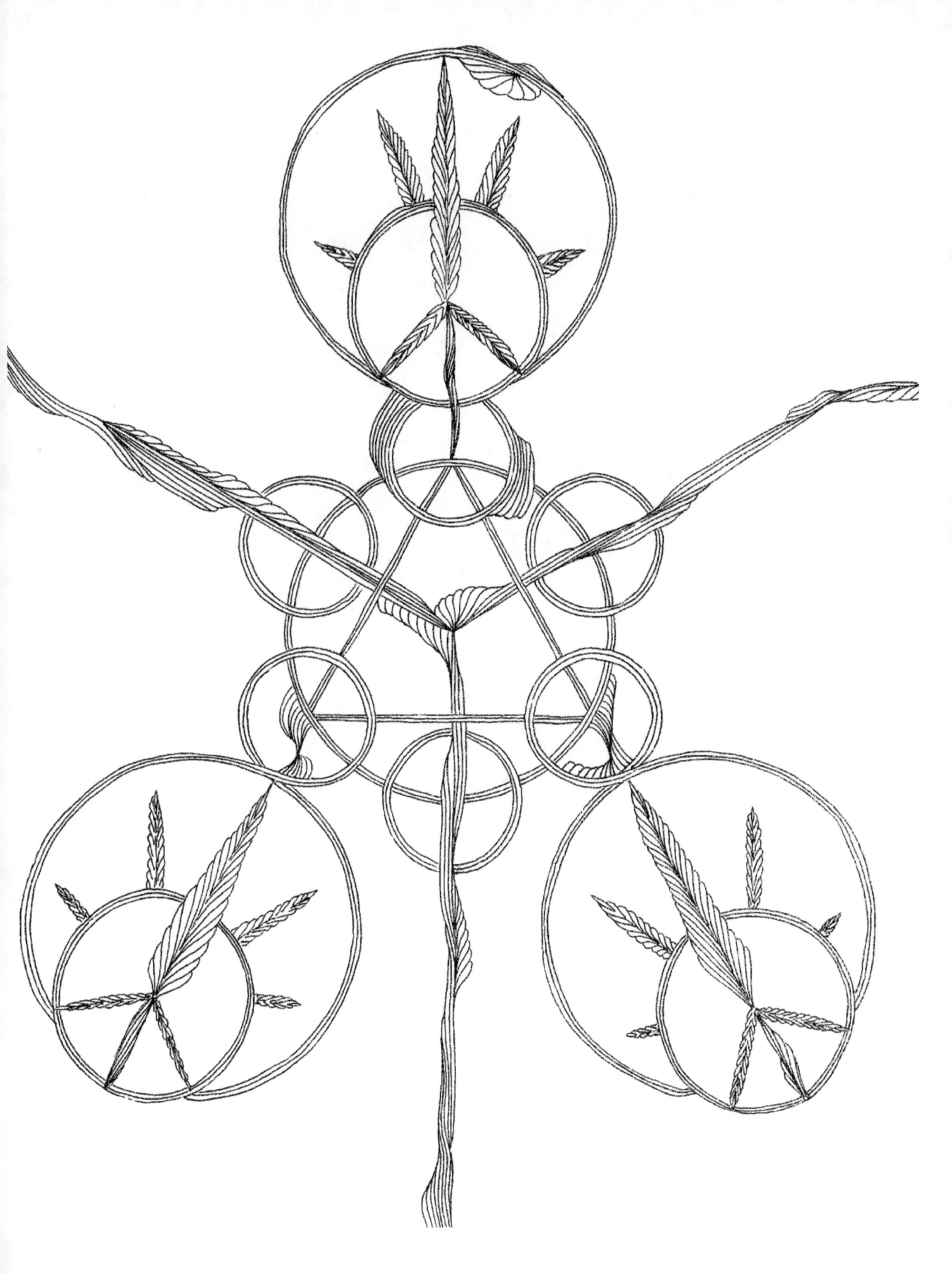

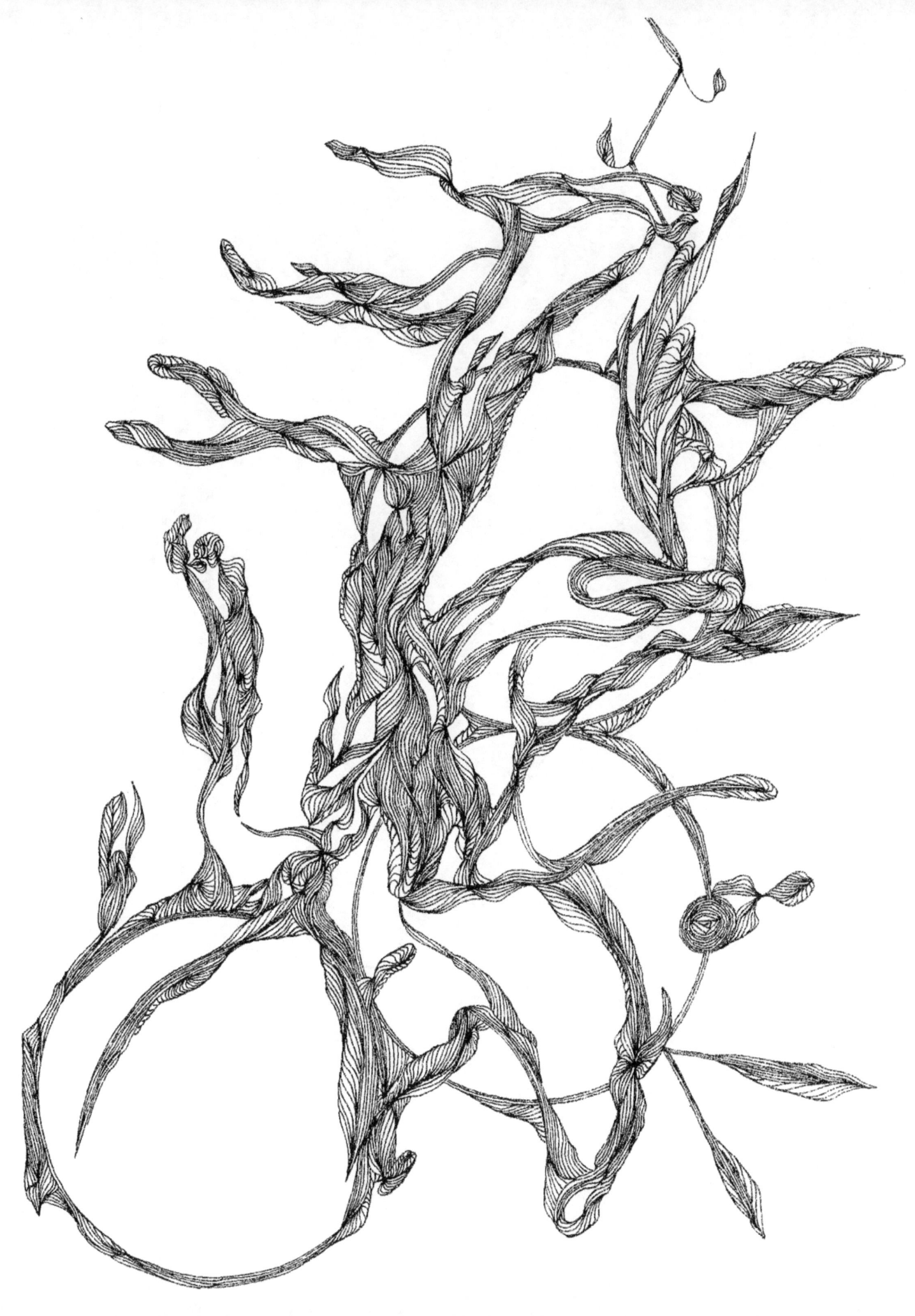

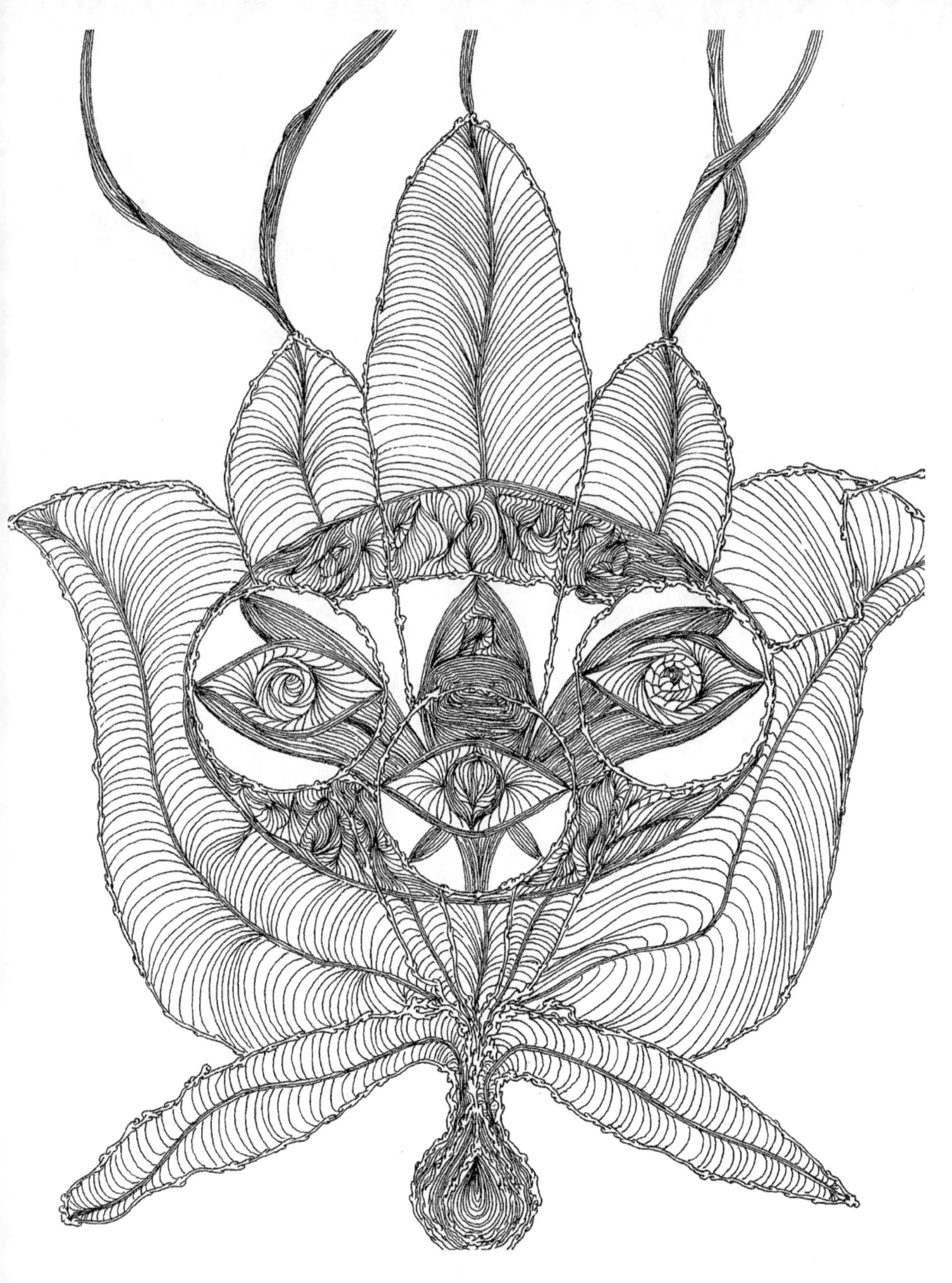

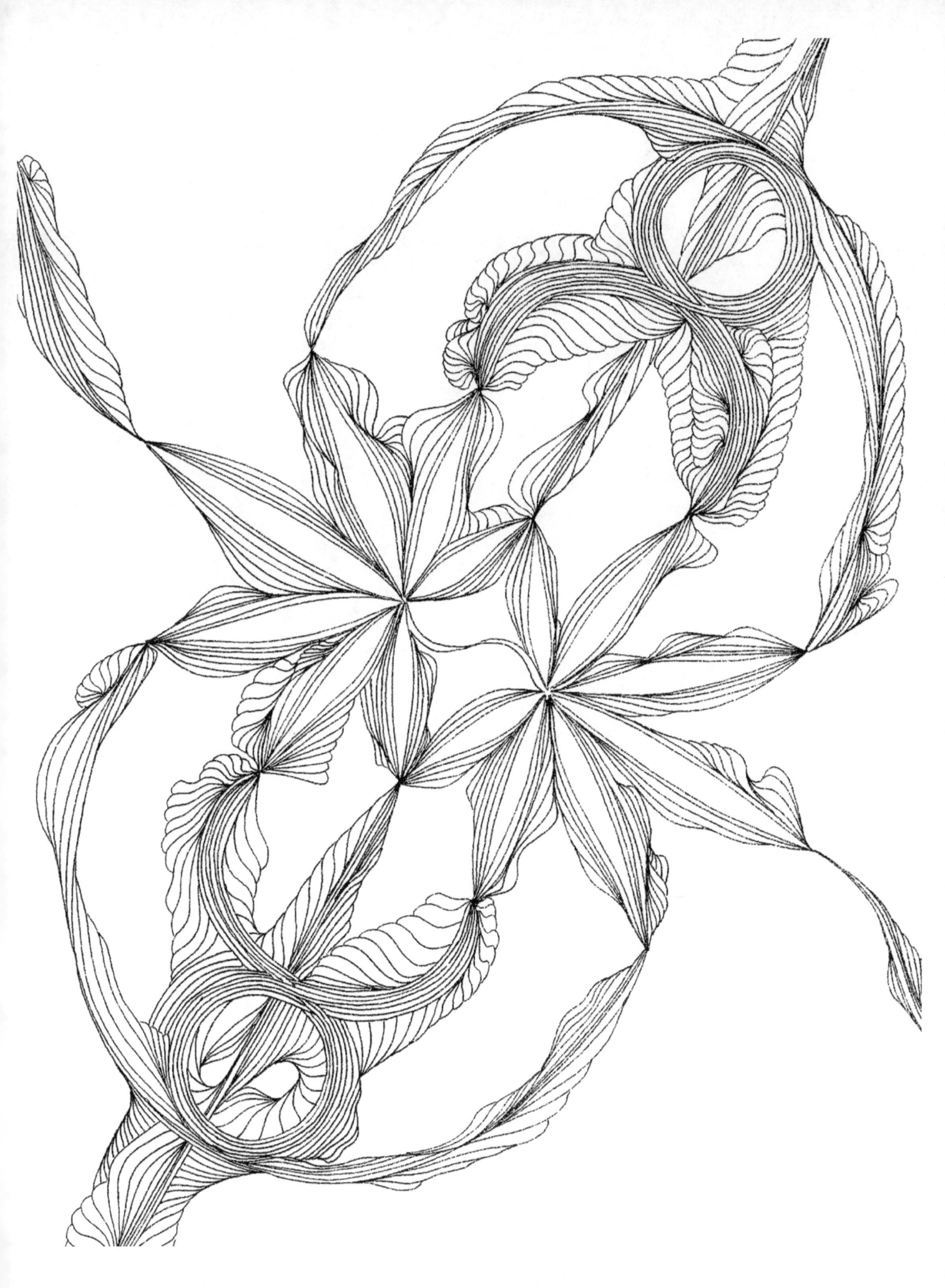

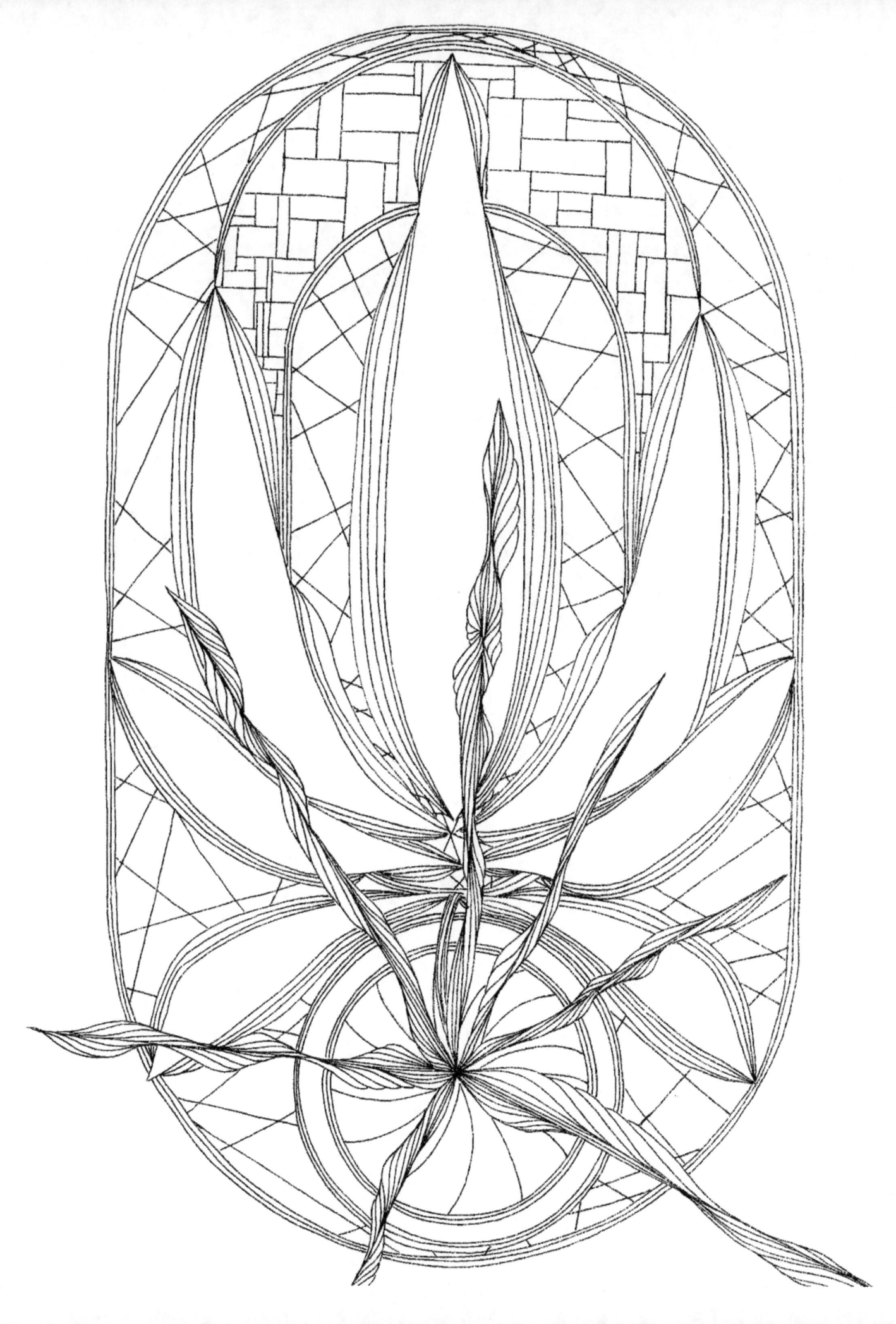

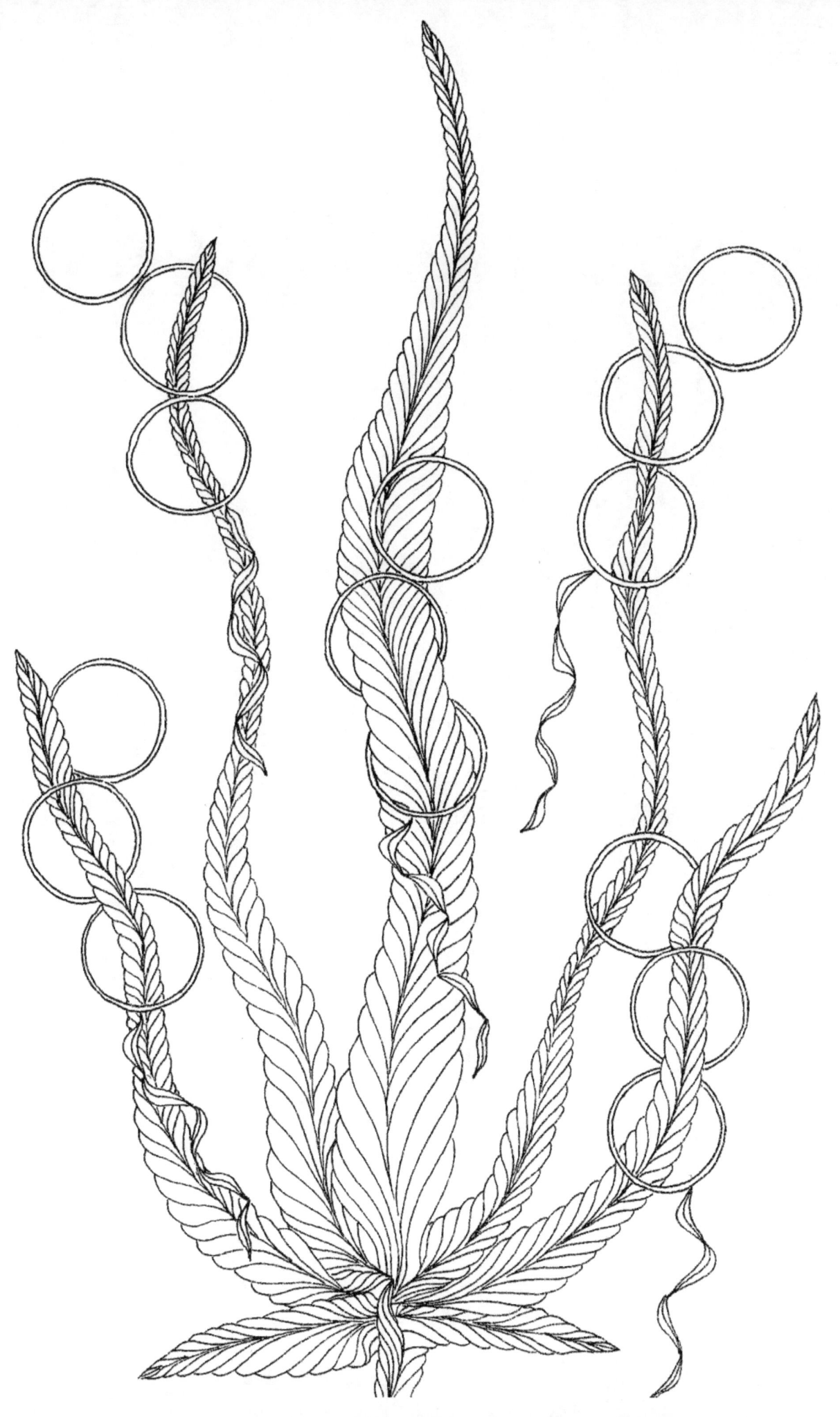

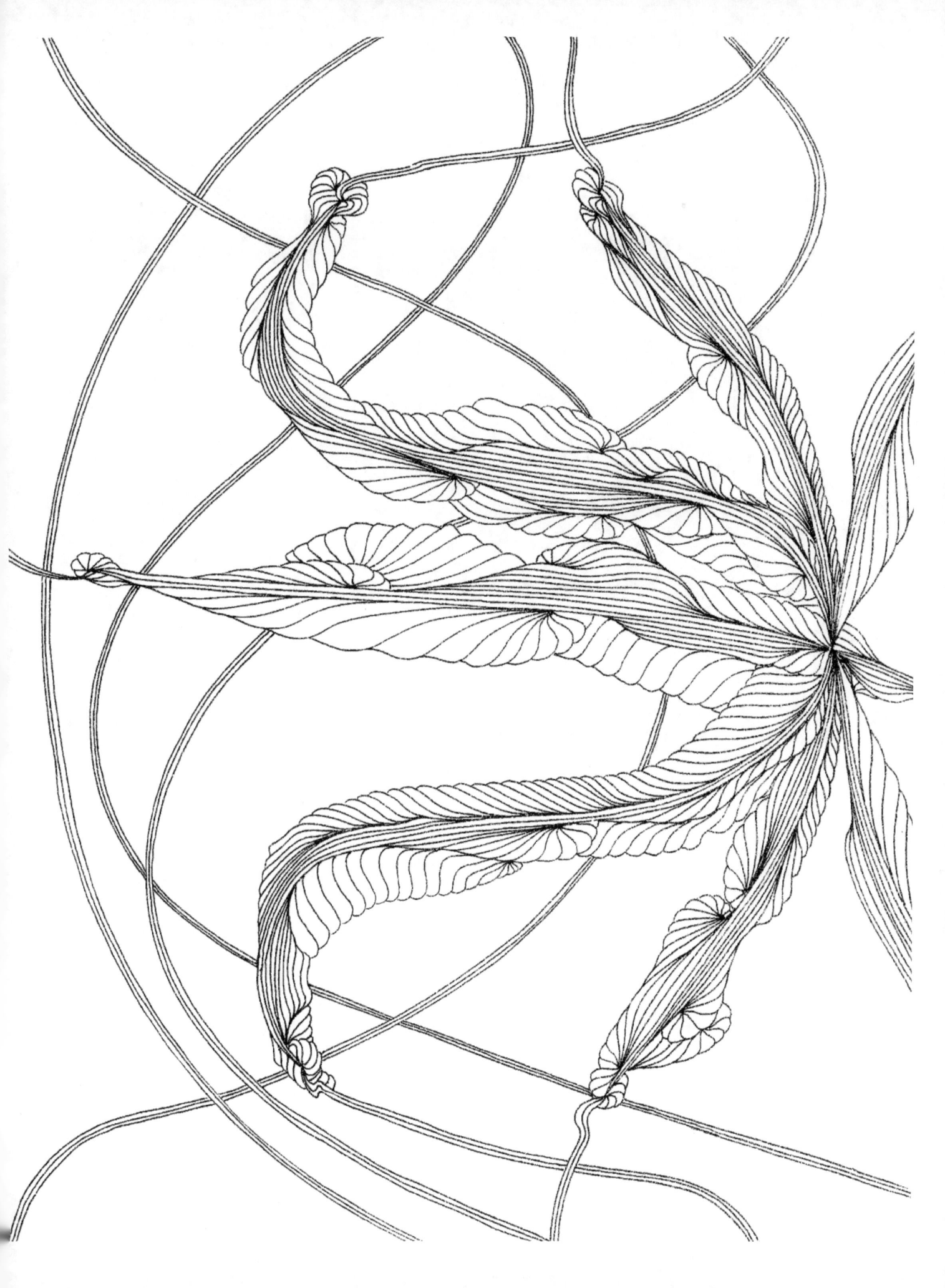

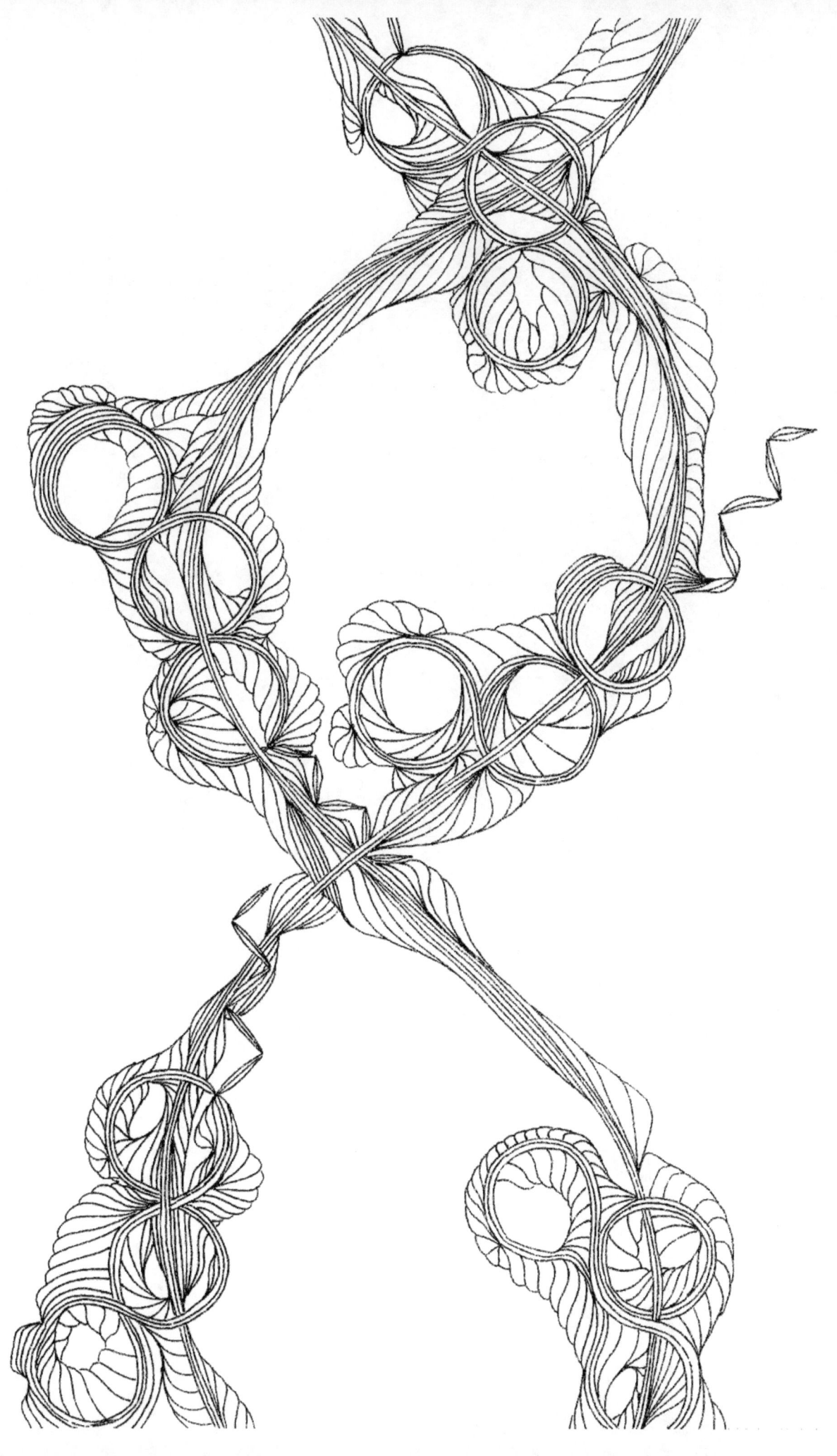

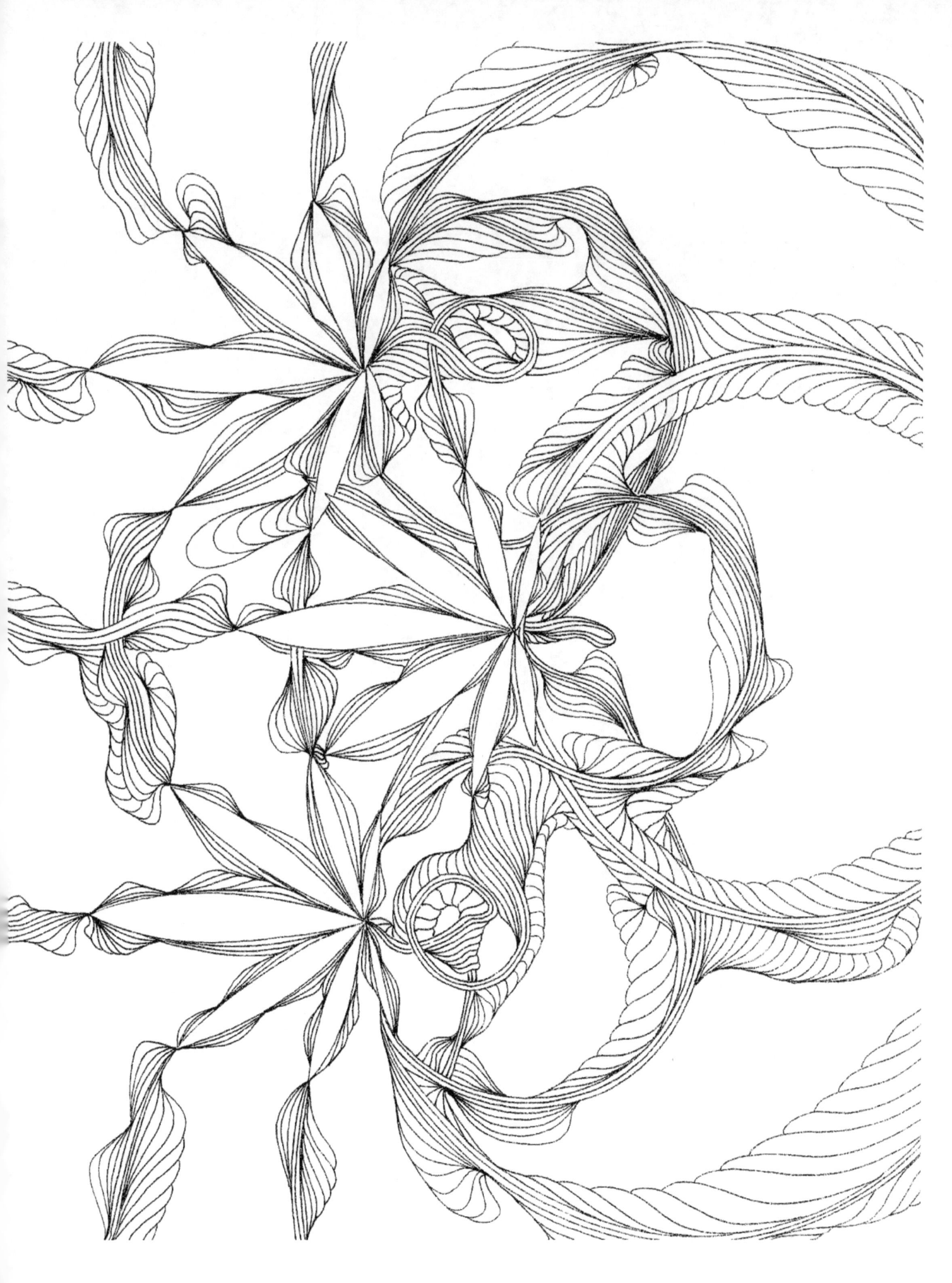

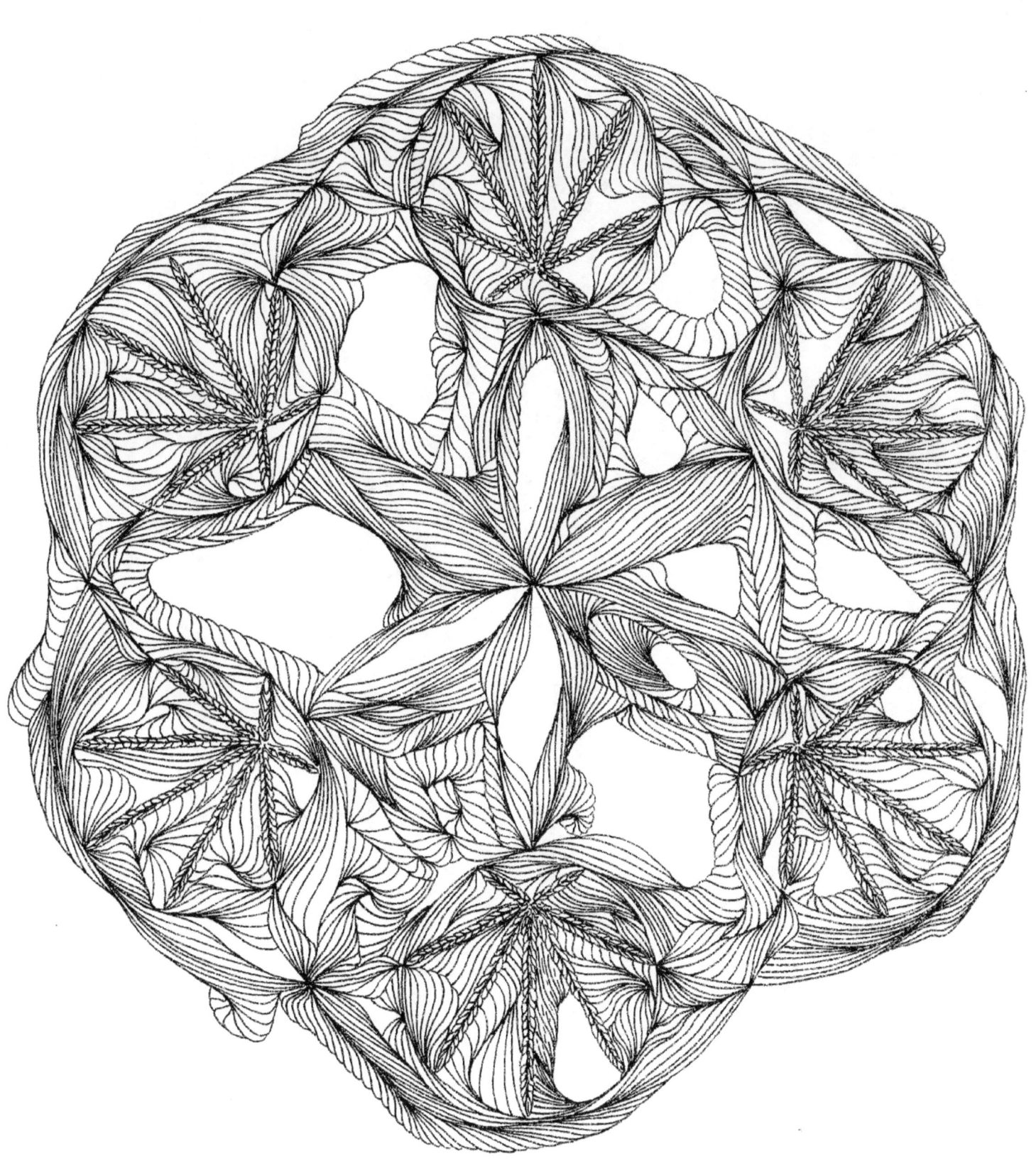

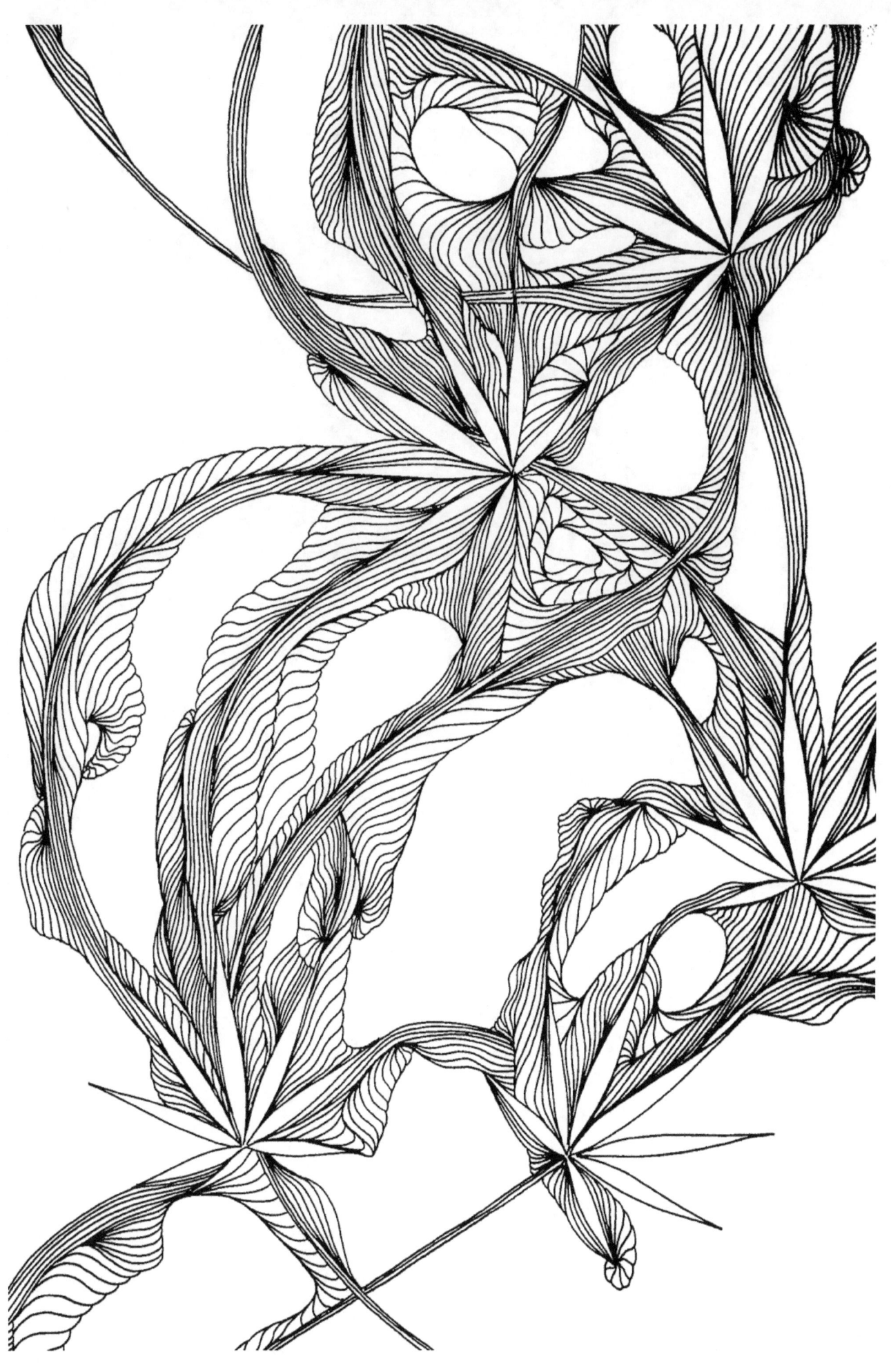

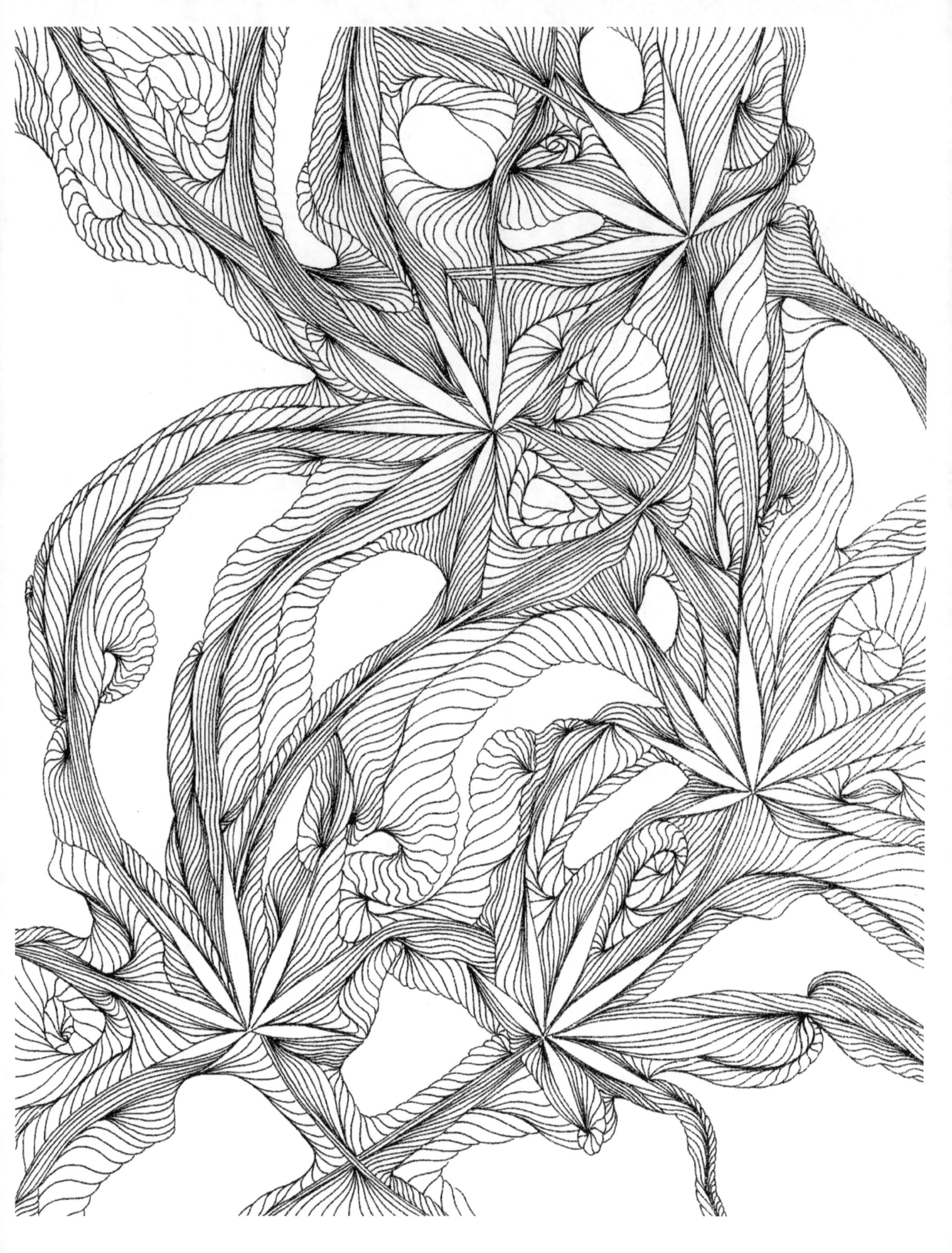

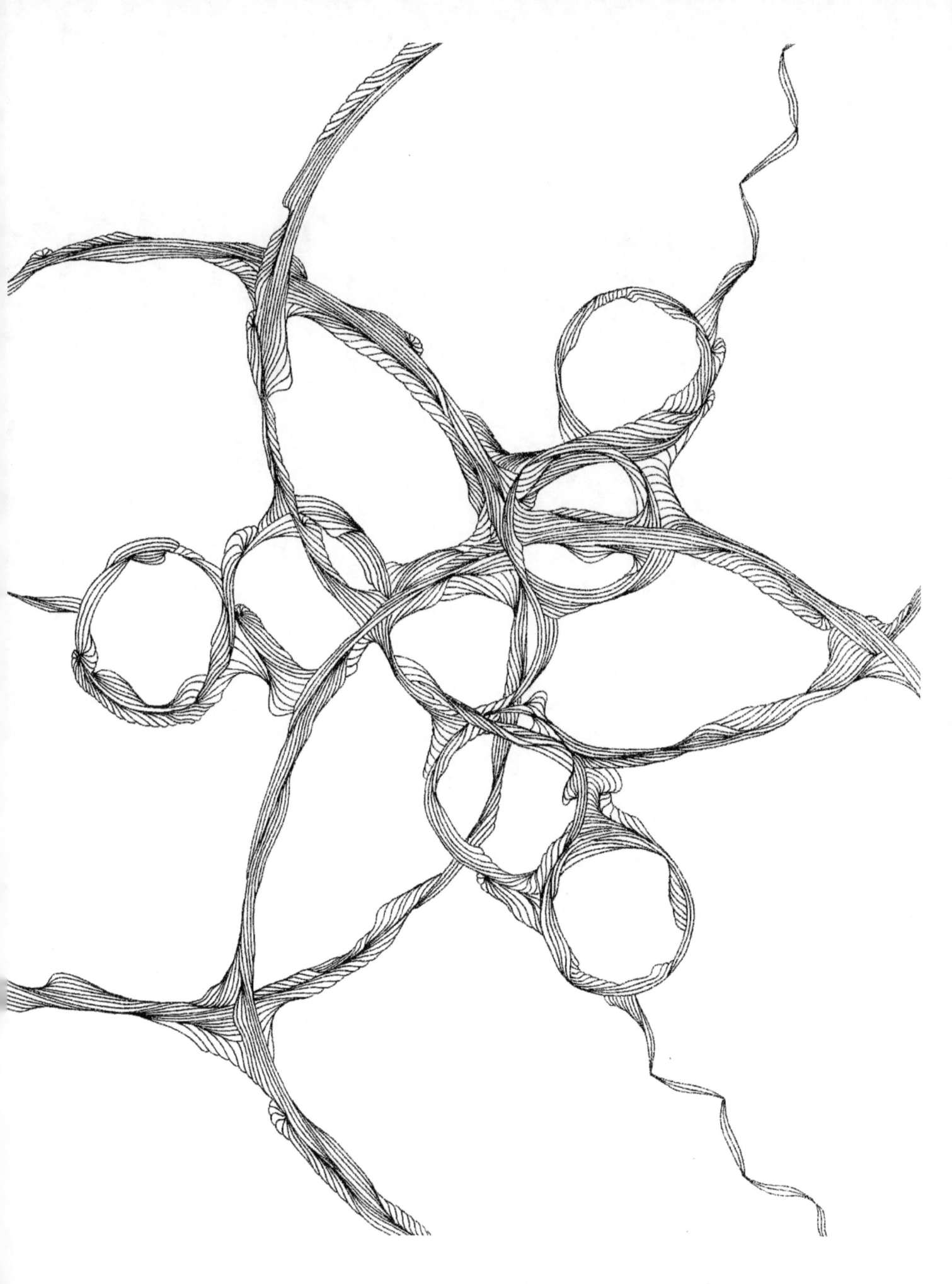

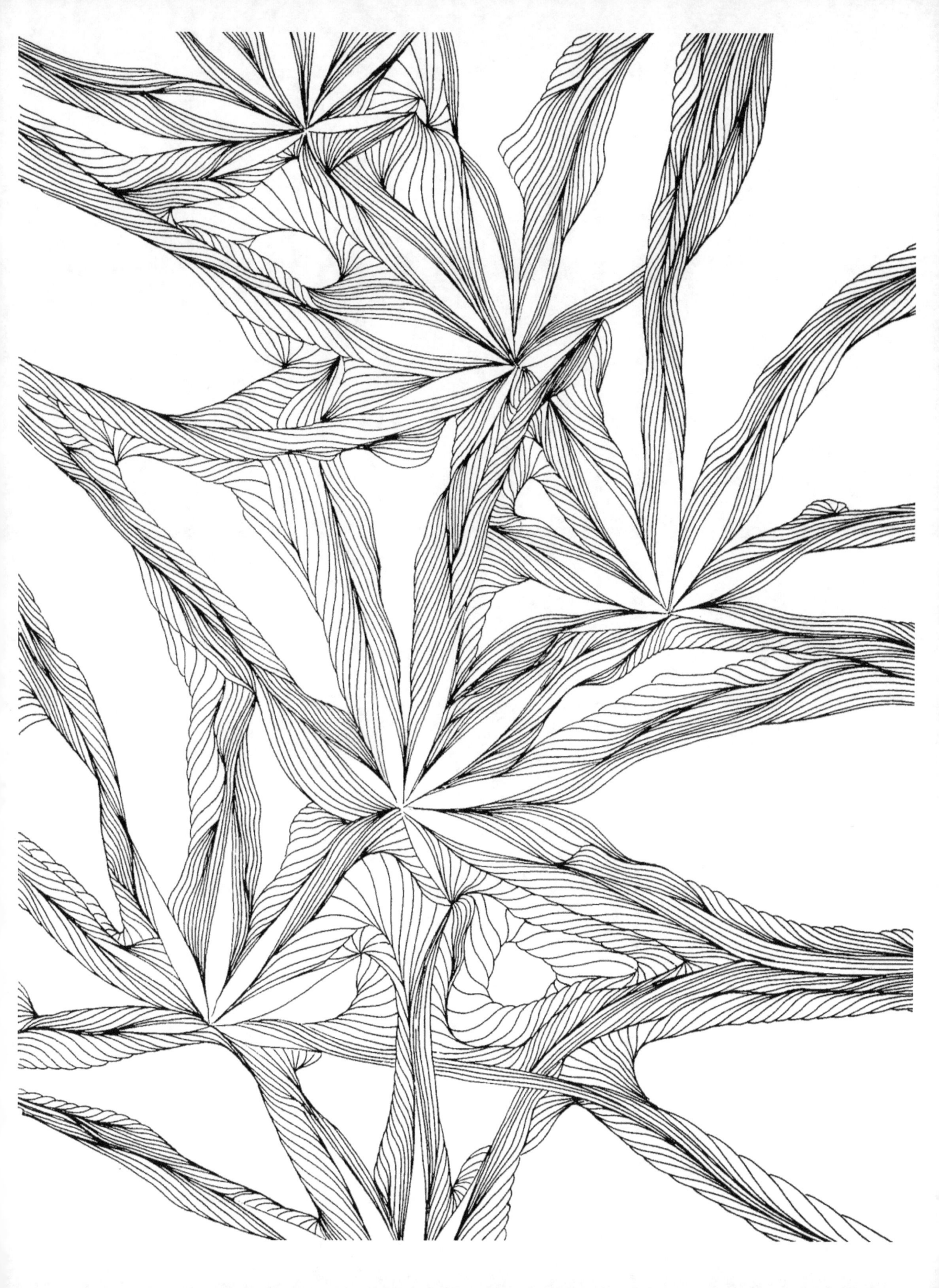

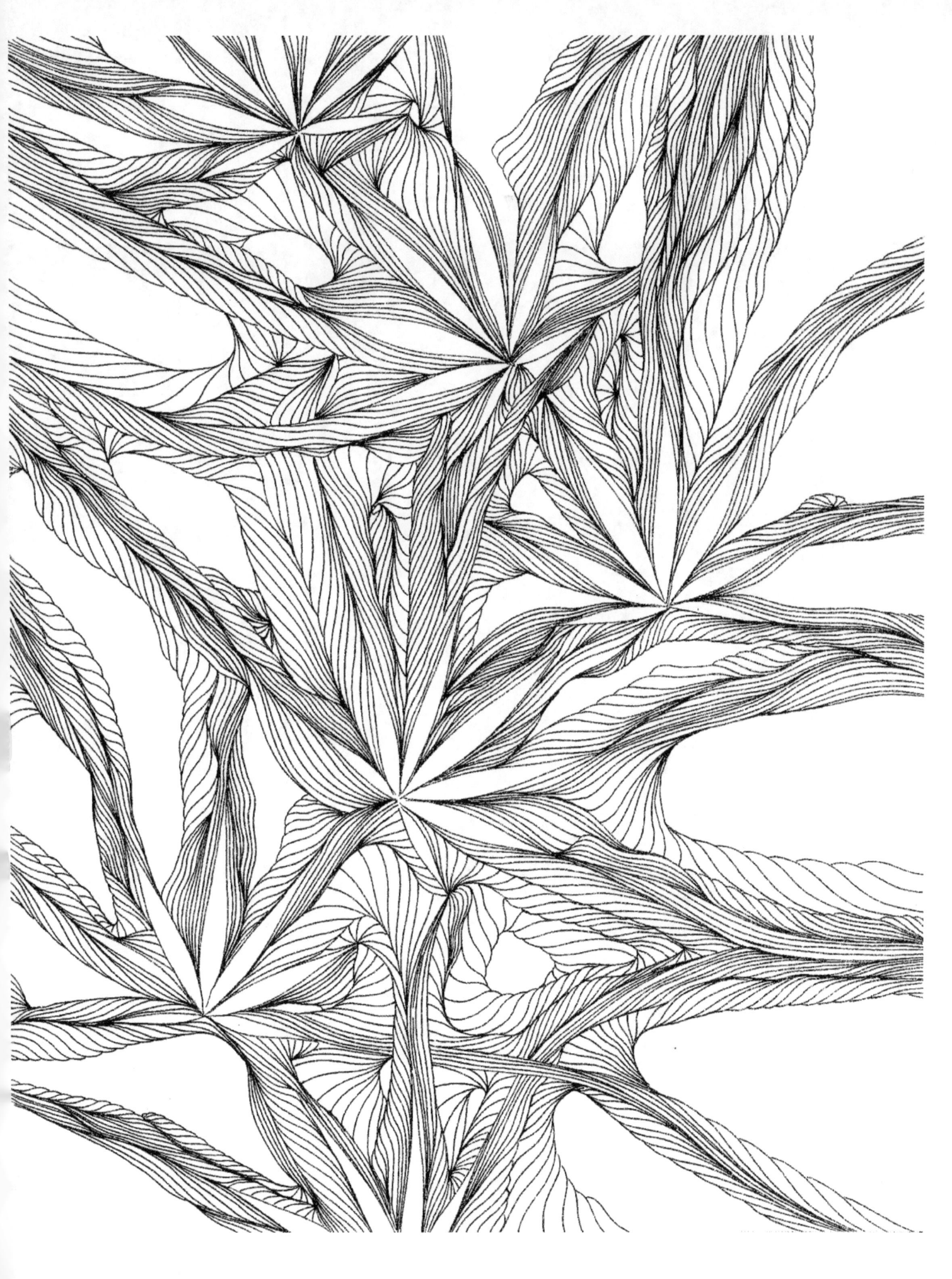

www.ingramcontent.com/pod-product-compliance
Lightning Source LLC
Chambersburg PA
CBHW080705190526
45169CB00006B/2244